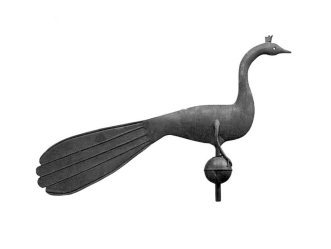

AMERICAN FOLK

Gerald W. R. Ward, Abaigeal Duda, Pamela A. Parmal, Sue Welsh Reed,
Gilian Ford Shallcross, and Carol Troyen

Folk Art from the Collection of the Museum of Fine Arts, Boston

MFA PUBLICATIONS
a division of the Museum of Fine Arts, Boston

MFA PUBLICATIONS
a division of the Museum of Fine Arts, Boston
295 Huntington Avenue
Boston, Massachusetts 02115

Published in conjunction with the exhibition
"American Folk," organized by the Museum of Fine
Arts, Boston, from April 8, 2001, to August 5, 2001.

This publication was made possible by the generous
support of Joan and Gerald O'Neil in honor of Gilian
Ford Shallcross.

Front cover (clockwise, details): Mary Ann Willson,
Young Woman Wearing a Turban (p. 28); John Green
Satterley, *Whirligig: Army Signalman* (p. 30); Unidentified
artist, *Peacock weather vane* (p. 52); Wilhelm Schimmel,
Lion (p. 49)
Back cover (clockwise, details): Unidentified artist,
Tomatoes, Fruit, and Flowers (p. 85); Mary Fleet, *Piping
Shepherd and Shepherdess* (p. 27); Unidentified artist,
Young Lion (p. 51)
Frontispiece (detail): Mary Simon and others,
Album quilt (p. 100)

Acknowledgment is made to Princeton University
Press for permission to reprint Jean de la Fontaine's
"The Kiss Returned," translated by N. R. Shapiro,
from *La Fontaine's Bawdy: Of Libertines, Louts, and Lechers.*
Used by arrangement with Princeton University Press.

ISBN 0-87846-595-2 (hardcover)
ISBN 0-87846-594-4 (softcover)
Library of Congress Card Number: 00-102998

Designed by Cynthia Rockwell Randall

Available through D.A.P./Distributed Art Publishers
155 Sixth Avenue, 2nd floor
New York, New York 10013
Tel.: 212 627 1999 · Fax: 212 627 9484

FIRST EDITION
Printed and bound in Italy

Contents

Foreword

THIS BOOK AND THE EXHIBITION that it accompanies celebrate both the pioneering and the developing collection of American folk art at the Museum of Fine Arts, Boston. Although a few examples of folk art entered the collection at an early date, the core of the Museum's collection of folk paintings, works on paper, and sculpture was assembled beginning in the mid 1940s by our exuberant and far-sighted patron, Maxim Karolik, whose passion for the subject was enormous. Erastus Salisbury Field's *The Garden of Eden*, and the highly important pictorial quilt made by Harriet Powers, who was born a slave, are among the works that came to the Museum thanks to Karolik's generosity and discerning eye. As you will read in this book, many other collectors and supporters have enriched our collections in more recent times, filling gaps and setting out in new directions, and we have made notable acquisitions of vernacular furniture and added such major works as the vibrant Baltimore album quilt and the stoneware storage jar by Dave the Potter pictured in the pages that follow.

An interdepartmental team of staff members wrote this book and organized the related exhibition "American Folk." Led by Gerry Ward, Katharine Lane Weems Curator of Decorative Arts and Sculpture, and Carol Troyen, Curator of Paintings, Art of the Americas, the team included Pamela Parmal, Curator of Textile and Fashion Arts, Sue Welsh Reed, Curator of Prints and Drawings, and Gilian Ford Shallcross, Manager of Exhibition Resources, Department of Education. They were ably assisted by Abaigeal Duda, research fellow and exhibition coordinator. As always, many other Museum staff members have contributed their efforts to the production of this book, and we express our thanks to them here.

Above all, we are profoundly grateful to our friends Joan and Gerald O'Neil for their generous support of this publication, made through a gift in honor of Gilian Ford Shallcross.

MALCOLM ROGERS
Ann and Graham Gund Director

Attributed to Eunice Williams Metcalf (born about 1775), *Bed rug* (detail), 1790–1800.

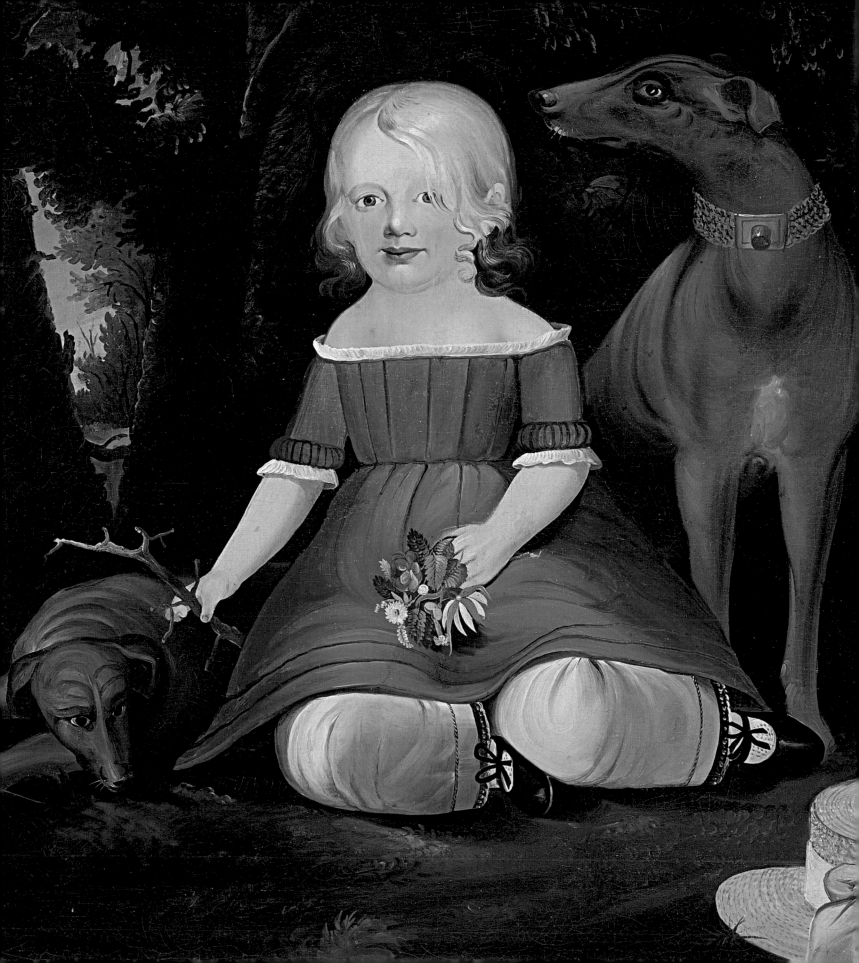

"Art for the Nation": American Folk Art and the Museum of Fine Arts, Boston

FOLK ART IS AN EXTRAORDINARILY popular, as well as a highly controversial, subject. The term itself is more generally understood than precisely defined; when pressed for a definition, people often simply remark that "they know it when they see it." Because of this vagueness, folk art has generated a good deal of heated debate among the many people who admire, study, and collect it. Determining whether or not a given work of art is folk can and often does raise thorny issues involving social class, cultural hierarchy and power, ethnic identity, taste, and relative aesthetic quality. Frequently such discussions are colored, consciously or not, by vested interests among dealers, collectors, and institutions.[1]

Broadly speaking, folk art is an umbrella term that covers many types of artistic expressions, once often called "primitive," "rustic," or "naïve," but now more likely to be referred to as nonacademic, amateur, self-taught, popular, provincial, rural, vernacular, or (in the case of twentieth-century work) outsider. When looked at closely, the term means different things to different people, and its meaning has changed over time. In a formal sense, prevalent in the academy and based on nineteenth-century European concepts, folk art reflects the attitude of tightly knit communities inhabited by people who share a common background or nationality and who tend to preserve their traditional arts rather than respond to outside influences. Since the 1930s, many collectors, dealers, and art museums have used the term to describe the work of primarily self-taught artists or craftsmen who, although trained in the apprenticeship system, practiced outside the boundaries of high or academic art. In many cases, however, these works simply are not part of any traditional folk life or culture in the previously accepted sense. Today, many types of objects are considered folk art

from the "classic" period in America, often defined as about 1776 to 1876, or before the era of industrialization.[2]

Any list of the types of folk art is therefore lengthy, and probably none can be complete. Perhaps the largest body of material consists of paintings and works on paper—often portraits, landscapes, still lifes, or religious subjects—by untrained or partially trained artists. Rural furniture is often considered to be folk when embellished with colorful painted graining or scenes of flowers, birds, or people. Sculpture and wood carvings of many types, including (but not limited to) animals and decoys, cigar-store Indians, whirligigs, and figural works of national heroes, form another broad category. To many, schoolgirl needlework, and quilts, coverlets, hooked rugs, and other textiles made by women in the home are key folk objects. Folk ceramics include, for example, stoneware with flowers, birds, or other scenes in bright cobalt-blue decoration, and sgrafitto-decorated redware, as well as the inexpensive chalkware figurines so loved by early collectors. Shop and trade signs, game boards, doorstops, tramp art, windmill weights, canes, baskets, scrimshaw, ship's figureheads, household utensils— there is almost no limit to the kinds of objects that are considered folk art. Even some proto-industrial products, such as late nineteenth and early twentieth-century weather vanes and carousel figures, in which handwork had a large role, fall under the folk art rubric. Often the makers of these objects are not known today, although research over time has established the identities of many, and some have since become widely recognized.[3]

Much folk art is united by an originality of expression and a love of materials, colors, patterns, and forms; often this emphasis adds great visual appeal and a sense of joy to primarily utilitarian objects. For

1. William Mathew Prior (1806–1873), *William Allen* (detail), 1843.

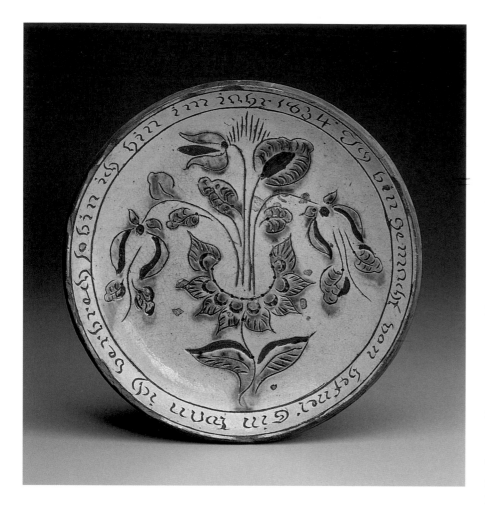

2. Attributed to John Neis (1785–1867),
Plate, 1834.

art—considered to be the art of the people, by the people, and for the people—was the most American of American art, and writers and enthusiasts often stressed its American-ness, in opposition to academic art tainted by its foreign origins.[5] More recently, it has been recognized that what is American about this art is largely that it was made here, often of local materials, and that the pictorial and figurative works usually depict local subjects. But perhaps the defining aspect of American folk art is that it embraces a multiplicity of folk traditions. In a country formed by immigration that did not have just a single "folk" class, as is often the case in European countries, a complex process of diffusion and assimilation shaped the look of objects. The attempt to understand this diversity—the opposite side of the traditional "melting pot" theory—and the tension between tradition, adaptation, and innovation are what give life and meaning to the study of American folk art.

THE CONCEPT OF CELEBRATING American folk art at the Museum of Fine Arts, Boston, would certainly have elicited some raised eyebrows from the Museum's founders. The idea of American folk art did not enter their thinking in 1876, when the MFA first opened its doors—nor could it, for the term itself did not come into common usage until half a century later. The principal goal of the Museum was to unite Art, Education, and Industry, and thus to educate the makers of industrial products and to elevate the taste of the general public, including recent immigrants, through exposure to the "fine arts." These were defined largely as the arts of ancient Egypt, Greece, and Rome; the exotic wares of the Near and Far East; and academic European and American paintings.[6] The thought of collecting and exhibiting com-

many early collectors, this ineffable quality of the object—its "spirit"—was of paramount concern. In more recent times, scholars have been interested in examining folk art and material culture more rigorously, whether it be eighteenth-century heart-and-crown chairs from coastal Connecticut or the painted work of Norwegian Americans of the upper Midwest in the nineteenth century, in order to understand these objects on their own terms, without condescension, as evidence of history and material life.[4]

Much early discussion of American folk art (as of American art as a whole) concerned defining its unique qualities. Folk

mercial and popular arts such as carousel figures, weather vanes, and decoys, now staples of folk art collections, would simply not have occurred to anyone at the time. The contributions of various immigrant groups, such as the Germans in Pennsylvania, were (with rare exceptions) similarly absent from the founders' paradigm: the fine art frame of reference, especially in New England, did not yet embrace or acknowledge the existence, much less the importance, of such "ethnic" materials. These were often regarded more as anthropological specimens or historical antiquities, and were thus within the purview of natural history or history museums.[7]

For more than sixty years, American folk art had a low profile at the MFA. The first American folk art collected here consisted of two Pennsylvania German sgrafitto redware plates (fig. 2) given anonymously by General Charles G. Loring in 1902. A few examples of schoolgirl needlework and rural painted furniture also could be found in the collection, but they had been acquired as examples of early Americana, rather than as part of a conscious attempt to collect folk art. In this manner, a Pennsylvania German painted chest signed by Christian Selzer was included in the massive bequest of Boston lawyer Charles Hitchcock Tyler in 1932.[8] Similarly, some carved figureheads, sternboards, and other objects sometimes classified today as folk were included in John Templeman Coolidge's gift of ship models and related arts in the 1930s, but the emphasis was on their maritime subject matter, rather than on any specific folk character.[9]

Beginning about 1930, through the efforts of Holger Cahill of the Newark Museum, the Museum of Modern Art in New York, and others, "folk art" became a popular subject for art museum exhibi-

tions and publications, largely because of its abstract qualities and its impact on then-contemporary painters and sculptors such as Charles Sheeler, Elie Nadelman, and Marguerite Zorach. Although the MFA acquired a major Sheeler in 1931, it did not aggressively collect the work of these modern painters, and thus may have had little interest in collecting the folk art source material that influenced their art.[10]

The major gift of the M. and M. Karolik Collection of Eighteenth-Century American Arts, opened to the public in 1941, dramatically increased the Museum's standing as a major repository of high-style American works.[11] While this collec-

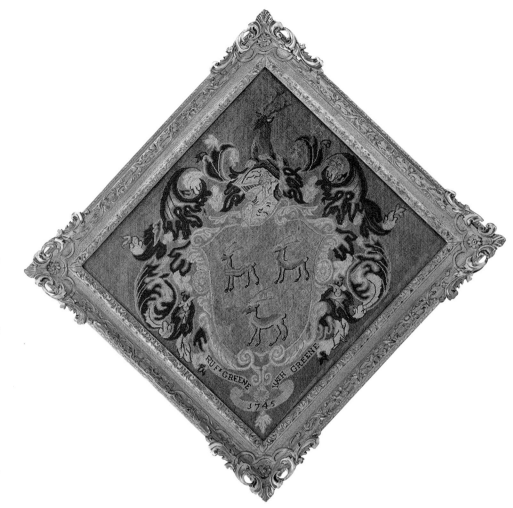

3. Katherine Greene (1731–1777), *Coat of arms*, 1745.

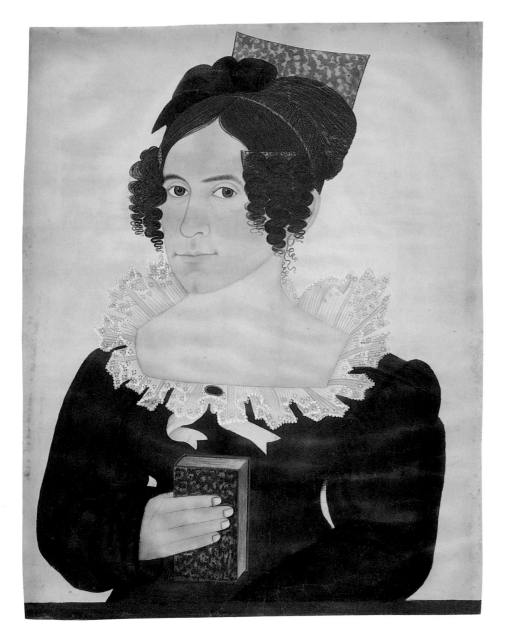

4. Mr. Willson (active early nineteenth century),
Miss Mary Furber, about 1822.

tion did include some needlework that can be considered folk art (fig. 3), its emphasis was on urban furniture, silver, Chinese export porcelain, imported glass, and other "elite" objects.

The Museum's collecting of decorative arts was paralleled (in an even more provincial manner) by its approach to acquiring American paintings. The emphasis for many years was placed on collecting the work of local Boston artists and portraits of the colonial New England gentry by the leading painters of the eighteenth century, among them John Smibert and John Singleton Copley. Early painting exhibitions were devoted to the works of William Morris Hunt, William Rimmer, and Gilbert Stuart, and after the turn of the century, the Museum's interests continued to focus on Boston-area painters, including Frank Benson, Edmund Tarbell, William MacGregor Paxton, and, notably, adopted son John Singer Sargent.[12]

In 1949, the collectors Martha Codman Karolik and her much younger and flamboyant husband, Maxim, gave the MFA a second great collection, entitled the "M. and M. Karolik Collection of American Paintings, 1815–1865." This group of more than two hundred major nineteenth-century works of art by artists largely unrecognized at the time, including Fitz Hugh Lane, Martin Johnson Heade, and others, also contained a substantial body of what Maxim Karolik referred to as "Primitive" paintings. Karolik had great admiration for these works. "The Primitives," he wrote, "are often fascinating in their technical artlessness, which is probably one cause of their appearing so genuine and so winning." Comparing these paintings with the products of more academically trained artists, he wondered "whether, from the artistic point of view, the question of Folk Art versus Academic Art has any meaning," ultimately concluding that it did not. In

the aftermath of World War II, this attitude made Karolik—a recent immigrant who had passionately adopted the ideals of his new country—an important proponent of the aesthetic quality of folk painting. "The primitive group in this collection," Karolik said of his gift, "will prove that among the unknown painters in this country were a number of men of exceptional talent. Fortunately, they had no academic training. Because of this they sometimes lacked the ability to describe, but it certainly did not hinder their ability to express." The collection included several works that have become icons of American folk art, including paintings by John Brewster, Erastus Salisbury Field, William Matthew Prior (fig. 1), and others, as well as important pictures by artists who have yet to be identified. The gift was recorded in a catalogue published that same year.[13]

While the Karoliks's second gift gave folk art its first major presence within the Museum, its standing was dramatically enhanced by the presentation of a third major collection from these same benefactors, in this case nineteenth-century American watercolors, drawings, and sculpture.[14] This comprehensive body of material, like the first two Karolik collections, was assembled with the help of the Museum's curators, and eventually included more than three thousand works on paper (fig. 4). Unlike the Karolik paintings catalogue, in which the "primitive" artists were seen as being an integral part of the overall spectrum, the catalogue of works on paper, published in 1962, segregated the "academic artists" in one volume from a substantial body of 350 portraits, landscapes, sandpapers, memorials, velvets, frakturs, and calligraphy by "folk artists" in another.

This collection instantly and permanently raised the MFA's stature in the realm of folk art. Works on paper by Ruth Henshaw

Bascom, Joseph H. Davis, Eunice Pinney, Mary Ann Willson, and dozens of other artists, many still unidentified, form a formidable body of material. The collection also contains more than seventy frakturs by Pennsylvania German artists—one of the first major groups of work by non-New Englanders to enter the American collections.

The folk section of the catalogue contained more than sixty three-dimensional objects classified as "sculpture," many of them acquired as complements to the works on paper. Most notably these included carved figures of famous Americans, many carved birds and animals (fig. 5), weather vanes, a whirligig, and a carousel rooster, as well as twenty one decoys. (Maxim Karolik was excited by the thought that decoys are "an art form

5. Unidentified artist (active late nineteenth century), *Fox on Log*, about 1850–1900.

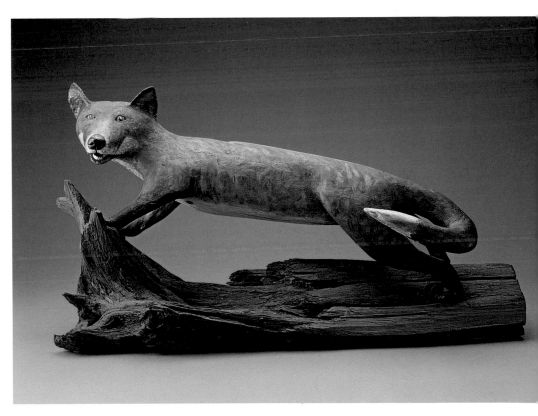

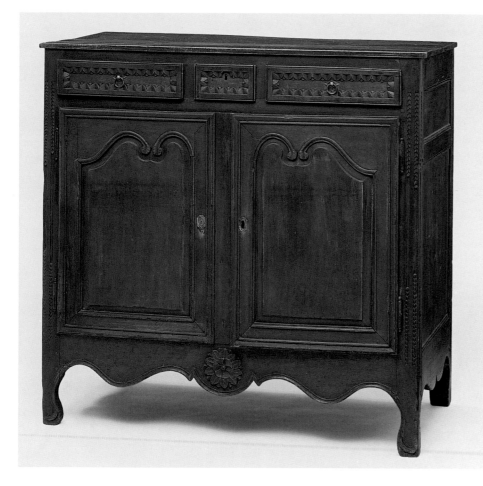

6. Attributed to Pierre Antoine Petit, called
La Lumière (died 1815), *Buffet*, about 1800.

indigenous to America.").[15] Carvings by Wilhelm Schimmel, even then a recognized "name," were well represented in the collection, including eagles of various sizes, roosters, birds, a lion, and a soldier. This group of folk sculpture embraces nearly all the newly accepted expressions at the time and reflects the approach to folk art taken by other major collectors of the period. With this third gift, the Karoliks largely achieved their ambitious goal of acquiring (in Maxim's words) "Art for the Nation," to be enjoyed at the Museum for generations to come.

IN THE PAST FEW DECADES, folk art has taken on an even greater presence at the MFA. While folk paintings were but one of many priorities for the former Department of Paintings, the collection was enriched by more than thirty works given between 1969 and 1981 by the prominent folk art collectors Edgar William Garbisch and Bernice Chrysler Garbisch. Since then the Museum has acquired several important folk paintings, among them *Reverend Jonas Coe* by Ammi Phillips and Susan Waters's masterpiece, *The Lincoln Children*.

Similarly, works of folk art have been part of the Museum's textile collection, even before the Textile Department was formally organized in 1930. These objects, due to their fragility and light sensitivity, normally lead a quiet life in storage with only a few examples on display at any given time. Foremost among them is the narrative quilt by Harriet Powers, a former slave who lived near Athens, Georgia. This pictorial quilt—arguably the single most important example of folk art held by the Museum—was another bequest from Maxim Karolik. Examples of schoolgirl art from New England of various types—needlework pictures, samplers (including a Boston one that entered the collection in 1877), quillwork, bed hangings, quilts—

are all part of the collection, but were acquired more for their quality than as a conscious effort to demonstrate various folk art traditions.

In the early 1970s, the Museum's collection of American decorative arts was largely focused on high-style objects from New England, mainly furniture and silver dating from the seventeenth century to about 1830. This situation began to change in the 1970s, as collecting activity in the folk art area followed the goal of demonstrating "the ethnic panorama of American art history."[16] For example, a pine trunk, made in Norway between 1800 and 1840, was purchased in 1977. Painted brightly in the traditional Norwegian style of *rosemaling* (rose painting), it was brought to Hillsboro County in North Dakota by immigrants about 1880, and demonstrates one means by which European (and other foreign) decorative traditions came to this country. A buffet (fig. 6) from Vincennes, Indiana, made about 1800 in a small fur-trading community in the upper Mississippi River Valley, closely resembles French provincial prototypes from Normandy, as well as from French Canada, where its maker was trained.[17] A large wardrobe (fig. 7) by Heinrich Kuenemann II of Fredericksburg, Texas, was made about 1870 in a small community in west Texas that was populated heavily by German Americans who came to America in the second great wave of German immigration. Made in a traditional Continental form, the wardrobe is fashioned of local pine with a spectacular, wavy grain, and embellished with mass-produced colonnettes and drawer pulls, thus illustrating the themes of persistence and assimilation that characterize much vernacular furniture.[18]

More traditional areas of folk art have also been collected in recent decades. For example, a small limestone statue of Napoleon (fig. 8) from the second quarter

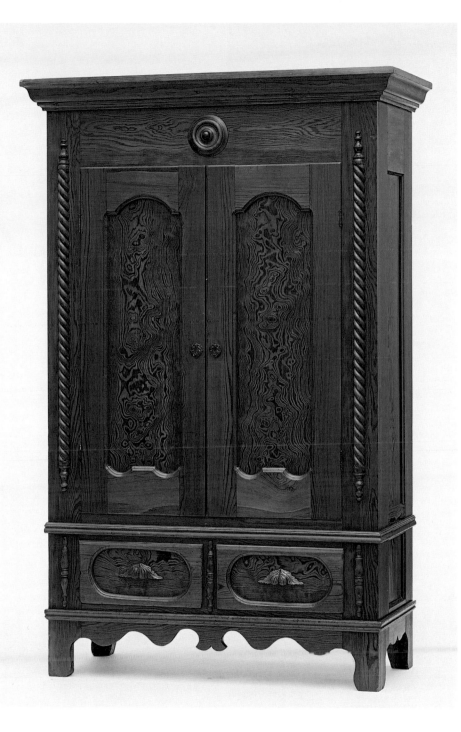

7. Heinrich Kuenemann II (1843–1914), *Wardrobe*, about 1870.

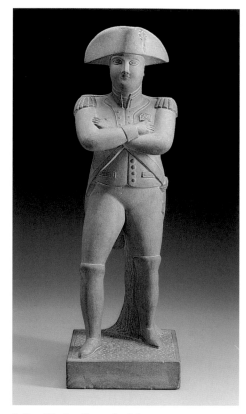

8. Possibly by Alexander Masterton
(1797–1859), *Napoleon*, about 1825–50.

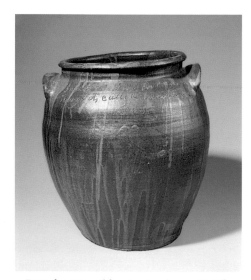

9. Dave the Potter (about 1783–about 1863) for
the Lewis J. Miles Factory, *Storage jar*, 1857.

of the nineteenth century represents a
fine folk study of this popular subject
and provides an interesting contrast to the
Museum's collection of academic figurative
sculpture. Possibly made by the owner of
the stone quarry that supplied the material
for the Washington Monument, this figure
is skillfully carved, although somewhat
naïve in sculptural terms.

Still other objects represent the modern
continuation or revival of the folk tradi-
tion, such as southern face jugs by Burlon
Craig and Burgess Delaney, and a sweet-
grass basket by Mary Jackson from
Charleston, South Carolina, in the African-
American tradition. A large carved and
painted pine figure of Uncle Sam (fig. 10),
once thought to have been made in New
Hampshire about 1840, was actually carved
as a World War II memorial by James
Stephen Ginder, an ingenious millwright
at the Boston Navy Yard in Charlestown,
Massachusetts.[19]

In the mid 1980s, the Museum renewed
its interest in Native American art, and in
the 1990s began to take additional steps
toward collecting works from Canada,
Central America, and South America.[20]
Some of these objects—such as Southwest
Indian pottery and baskets, a Peruvian
armario of about 1600, Santos from Puerto
Rico, furniture from French Canada,
Mexico, and Bermuda—were displayed in
an experimental gallery entitled "American
Traditions: The Art of the People," which
opened in 1997.[21] Here, drawing upon the
thought expressed by poet Walt Whitman
that America "is not merely a nation but
a teeming Nation of nations," objects
expressive of many different traditions,
indigenous and immigrant, were brought
together to illustrate the rich ethnic and
regional diversity of America. Works by
artisans influenced to various degrees by
their African, Dutch, English, French,

German, Italian, Spanish, and other cultur-
al heritages illustrate the complex process
of importation, diffusion, assimilation,
and adaptation that characterizes art of this
kind. A *kast* of about 1790–1810, attributed
to Roelef Demarest of northern Bergen
County, New Jersey, for example, while
not considered "folk" by everyone,
demonstrates the persistent strength of a
Dutch tradition in the greater New York
area. A massive stoneware jar (fig. 9) made
by Dave the Potter in Edgefield County,
South Carolina, at the factory of his white
owner, Lewis J. Miles, shows in superb
fashion the achievement of the only slave
allowed to sign his work in antebellum
America. Dave also incised a rhymed cou-
plet on this large jar ("I made this Jar for
Cash/though its called lucre trash") and
dated it August 22, 1857. His handsome,
thick-walled vessel is testimony to Dave's
technical prowess, to his literacy, and to
what must have been a strong and power-
ful personality. While this gallery repre-
sents only a small step—obviously not
every type of object or every immigrant
tradition can be represented in such a
small space—it demonstrates the impor-
tance of recognizing the broad panorama
of the arts in the Americas.[22]

IN THE LAST SIXTY YEARS, the Museum of
Fine Arts has been moving increasingly
toward representing the best works of art
from the protean country that is America,
by collecting and exhibiting the best that
each generation of artists and craftsmen
has produced. Folk art is clearly part of
the Museum's mission to collect, preserve,
exhibit, and interpret the many great
achievements of all Americans over time
and across space. Whether the works of art
are high-style or vernacular, city or coun-
try, academic or popular, domestic or
commercial, fine or folk, is not as critical

as the quality of the individual object. Although taxonomy is important, what also matters in the end is the work of art's manifold characteristics: its maker, its regional origin, and its medium, but also its impact and its importance as art, history, and material culture. The key to each piece in the art museum context is, in Maxim Karolik's words, its "ability to express" and to generate a greater understanding of the human condition.

In the following pages, about sixty works from the MFA's collection are illustrated and discussed. Our goal has been to provide a sampler of the Museum's rich holdings of folk art, and to group them in visually pleasing and interesting juxtapositions that demonstrate the crosscurrents in techniques and motifs among artists and craftsmen in different media. Many of these objects are among the best known and best loved works in the collection; others are introduced here to the public for the first time. It is our hope that they all will provide a fascinating glimpse into life in America from the late eighteenth to the early twentieth century.

GERALD W. R. WARD

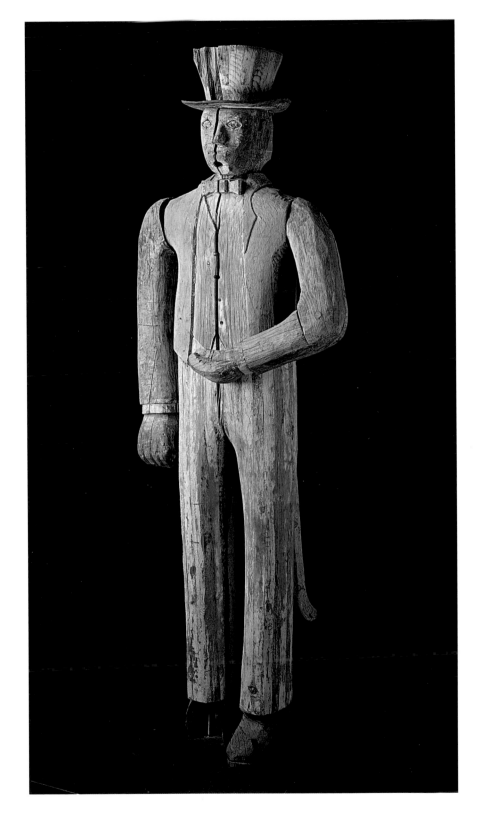

10. James Stephen Ginder (1871–1949), *Uncle Sam*, about 1943.

1. The writer is grateful to his fellow members of the Folk Art Team for their assistance, to Jeannine Falino and Rebecca Reynolds of the Art of the Americas department, to MFA archivist Maureen Melton, and to Barbara McLean Ward for her careful reading of several drafts.

The literature on American folk art is vast and of greatly varying usefulness. Much of the controversy surrounding the definition of the term can be found in Ian M. G. Quimby and Scott T. Swank, eds., *Perspectives on American Folk Art* (New York: W.W. Norton for the Henry Francis du Pont Winterthur Museum, 1980), and in Kenneth L. Ames, *Beyond Necessity: Art in the Folk Tradition* (Winterthur, Del.: Winterthur Museum, 1977). Classic definitions of the traditional viewpoints toward folk art can be found in Jean Lipman, Robert Bishop, Elizabeth V. Warren, and Sharon L. Eisenstat, *Five Star Folk Art: One Hundred American Masterpieces* (New York: Harry N. Abrams in association with the Museum of American Folk Art, New York, 1990) and Robert Bishop and Jacqueline Marx Atkins, *Folk Art in American Life* (New York: Viking Studio Books, 1995). Henry Glassie is perhaps the most eloquent explicator of the meaning of folk art; among his many publications, see, for example, *The Spirit of Folk Art: The Girard Collection at the Museum of International Folk Art* (New York: Harry N. Abrams in association with the Museum of New Mexico, Sante Fe, 1989). For help with the literature, see Simon J. Bronner, *American Folk Art: A Guide to Sources* (New York and London: Garland Publishing, 1984).

Because of the nature of the Museum's collection at the present time, this publication and exhibition are focused almost entirely on works of art made before 1920, and principally in the period from roughly 1780 to 1900, in what is now the United States. Works by Native Americans (well represented at the Museum but falling outside the parameters of this project), folk art from Central and South America, and twentieth-century "outsider" and other types of folk art are therefore not included.

2. David Tatham, "Museums and the 'Art of the Common Man': The Birth, Growth, and Troubled Life of the Concept of 'American Folk Art'" (unpublished manuscript, 1988), contains an excellent discussion of the shifting meanings of folk art within the art museum context.

3. A thumbnail guide to the generally accepted categories (other than ceramics and furniture) is conveniently supplied in two volumes of the Knopf Collectors' Guides to American Antiques: Robert Bishop, Judith Reiter Weissman, Michael McManus, and Henry Niemann, *Folk Art: Paintings, Sculpture, and Country Objects* (New York: Alfred A. Knopf, 1983) and Robert Bishop, William Secord, and Judith Reiter Weissman, *Quilts, Coverlets, Rugs, and Samplers* (New York: Alfred A. Knopf, 1982).

4. See, for example, Robert F. Trent, *Hearts and Crowns: Folk Chairs of the Connecticut Coast, 1710–1840, as Viewed in the Light of Henri Focillon's Introduction to "Art Populaire"* (New Haven, Conn.: New Haven Colony Historical Society, 1977) and Marion Nelson, ed., *Norwegian Folk Art: The Migration of a Tradition* (New York: Abbeville Press in association with the Museum of American Folk Art, New York, and the Norwegian Folk Museum, Oslo, 1995).

5. See, for example, Peter C. Welsh and Anne Castrodale, *American Folk Art: The Art and Spirit of a People* (Washington, D.C.: Smithsonian Institution, 1965).

6. The standard institutional history is Walter Muir Whitehill, *Museum of Fine Arts, Boston: A Centennial History*, 2 vols. (Cambridge, Mass.: Belknap Press of Harvard University Press, 1970).

7. A good survey of the history of the field is David Park Curry, "Rose-Colored Glasses: Looking for 'Good Design' in American Folk Art," in *An American Sampler: Folk Art from the Shelburne Museum* (Washington, D.C.: National Gallery of Art, 1987), pp. 24–41.

8. For Tyler, see Elizabeth Stillinger, *The Antiquers* (New York: Alfred A. Knopf, 1980), pp. 95–104.

9. Maria Pulsone Woods and Rob Napier, "Ship Models at the Museum of Fine Arts, Boston: A Fresh Look," *Nautical Research Journal* 37, no. 4 (December 1992).

10. The relationship between folk art and modern art is illustrated in such publications as Jean Lipman, *Provocative Parallels: Naïve Early Americans/International Sophisticates* (New York: E.P. Dutton, 1975).

11. Edwin J. Hipkiss, *Eighteenth-Century American Arts: The M. and M. Karolik Collection* (Cambridge, Mass.: Harvard University Press for the Museum of Fine Arts, Boston, 1941).

12. See Theodore E. Stebbins, Jr., "A Local Duty: Collecting American Paintings at the Museum of Fine Arts, 1870–1995," in Carol Troyen et al., *American Paintings in the Museum of Fine Arts, Boston: An Illustrated Summary Catalogue* (Boston: Museum of Fine Arts, Boston, 1997), pp. xiii–xxix.

13. *M. and M. Karolik Collection of American Paintings, 1815 to 1865* (Cambridge, Mass.: Harvard University Press for the Museum of Fine Arts, Boston, 1949); the quotations from Karolik are on p. xii. This important catalogue contains a lengthy introductory essay by John I. H. Baur of The Brooklyn Museum and catalogue entries and biographies prepared by W. G. Constable, then the curator of paintings, who helped Karolik assemble the collection. In 1958 and 1962, respectively, two major folk paintings, the large group portraits of *Joseph Moore and His Family* by Erastus Salisbury Field and *The Reverend John Atwood and His Family* by Henry F. Darby, were added to the collection.

14. *M. and M. Karolik Collection of American Water Colors and Drawings, 1800–1875*, 2 vols. (Boston: Museum of Fine Arts, Boston, 1962). This catalogue was prepared by Henry F. Rossiter, the curator of prints and drawings who worked with Karolik to create the collection, Sue Welsh Reed, and other curators.

15. Rachel J. Monfredo, "Decoys in the Boston Museum of Fine Arts," *Decoy Magazine* 17, no. 1 (January/February 1993): 12–17.

16. See the introduction in Jonathan L. Fairbanks et al., *Collecting American Decorative Arts and Sculpture, 1971–1991* (Boston: Museum of Fine Arts, 1991). Fairbanks was the first curator of a new Department of American Decorative Arts and Sculpture, started by the MFA in 1971. Two loan exhibitions organized by the young department—one of Puerto Rico Santos figures held in 1972 and "Frontier America: The Far West," shown in Boston in 1975 and abroad in 1976—brought new materials and perspectives to the museum audience. In 1984 the MFA held a loan exhibition entitled "Carved and Painted," drawn from the outstanding New England collection of Bertram K. Little and Nina Fletcher Little and celebrating the publication of Mrs. Little's book on their collecting, *Little by Little*.

17. See catalogue entry by Edward S. Cooke, Jr., in *Collecting American Decorative Arts*, p. 47, and Douglas A. Wissing, "Persistence of Memory: French Furniture in Indiana," *Traces of Indiana and Midwestern History* 7, no. 3 (summer 1995): 40–43.

18. See catalogue entry by Edward S. Cooke, Jr., in *Collecting American Decorative Arts*, p. 48.

19. See Helen P. Frech's 1976 research paper in the data file for *Uncle Sam* (1967.763).

20. The MFA's collection of Southwest Indian pottery was recently highlighted in an exhibition at the Nagoya/Boston Museum of Fine Arts. See Linda Foss Nichols, *Voice of Mother Earth: Art of the Puebloan Peoples of the American Southwest* (Nagoya, Japan: Nagoya/Boston Museum of Fine Arts, 2000).

21. This gallery was organized by Linda Foss Nichols and Gerald W. R. Ward under the supervision of Jonathan L. Fairbanks. It is discussed in Timothy Schreiner, "A Democracy of Furniture," *Home Furniture*, no. 13 (October–November 1997): 54–59.

22. *The Harvard Encyclopedia of American Ethnic Groups* (Cambridge, Mass.: Harvard University Press, 1980), edited by Stephan Thernstrom, for example, has entries for 113 different groups, in addition to sections on indigenous peoples. Architectural historians have identified some 22 major ethnic building styles and types; see Dell Upton, ed., *America's Architectural Roots: Ethnic Groups That Built America* (Washington, D.C.: The Preservation Press, National Trust for Historic Preservation, 1986). See also Jon Butler, *Becoming America: The Revolution Before 1776* (Cambridge: Harvard University Press, 2000); Roger Daniels, *Coming to America: A History of Immigration and Ethnicity in American Life* (New York: HarperCollins, 1990); and an interesting older work: Allen H. Eaton, *Immigrant Gifts to American Life: Some Experiments in Appreciation of the Contributions of Our Foreign-Born Citizens to American Culture* (New York: Russell Sage Foundation, 1932).

Family
Album

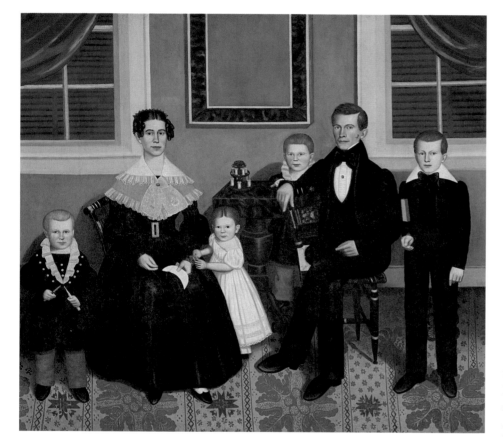

Erastus Salisbury Field

(1805–1900)

Joseph Moore and His Family, about 1839
Oil on canvas
82⅜ x 93⅜ in. (209.2 x 237.2 cm)
Gift of Maxim Karolik for the M. and M.
Karolik Collection of American Paintings,
1815–1865 58.25

In 1839, after a brief period of artistic train-
ing under Samuel F. B. Morse in New York
and more than a decade working successfully
in the Connecticut River Valley as a portrait
painter, Erastus Salisbury Field returned to
Ware, Massachusetts, to live with his in-laws.
Across the street lived the family of Joseph
Moore, a traveling dentist in the summer
when the roads were passable and a hatter
in the winter months. This portrait of Field's
neighbors was the largest and most complex
he ever painted.

Moore and his wife, Almira Gallond Moore,
are shown nearly life-sized, seated in gaily
painted Hitchcock chairs and surrounded by
attentive, neatly dressed children—their two
sons at right and their recently orphaned
niece and nephew at left. Like many folk
painters, Field combined careful attention to
detail (scrupulously recording Moore's birth-
mark, for example, and the ornate pattern of
Mrs. Moore's collar) with attractive eccentric-
ities of composition and drawing. The figures
and the features of the room are stringently
balanced. Field's perspective is haphazard: the
mirror's shadow recedes in the wrong direc-
tion, while the patterned carpet is not fore-
shortened and so appears to run uphill. And
the children look like little elves, with pointy
ears and stubby fingers.

The portrait remained in the Moore family
until 1958, when Maxim Karolik bought it
for the MFA. At the same time, the family
presented the Museum with the chairs, mir-
ror, and jewelry depicted in the portrait, as
well as Moore's dental tools and other objects
associated with the family.

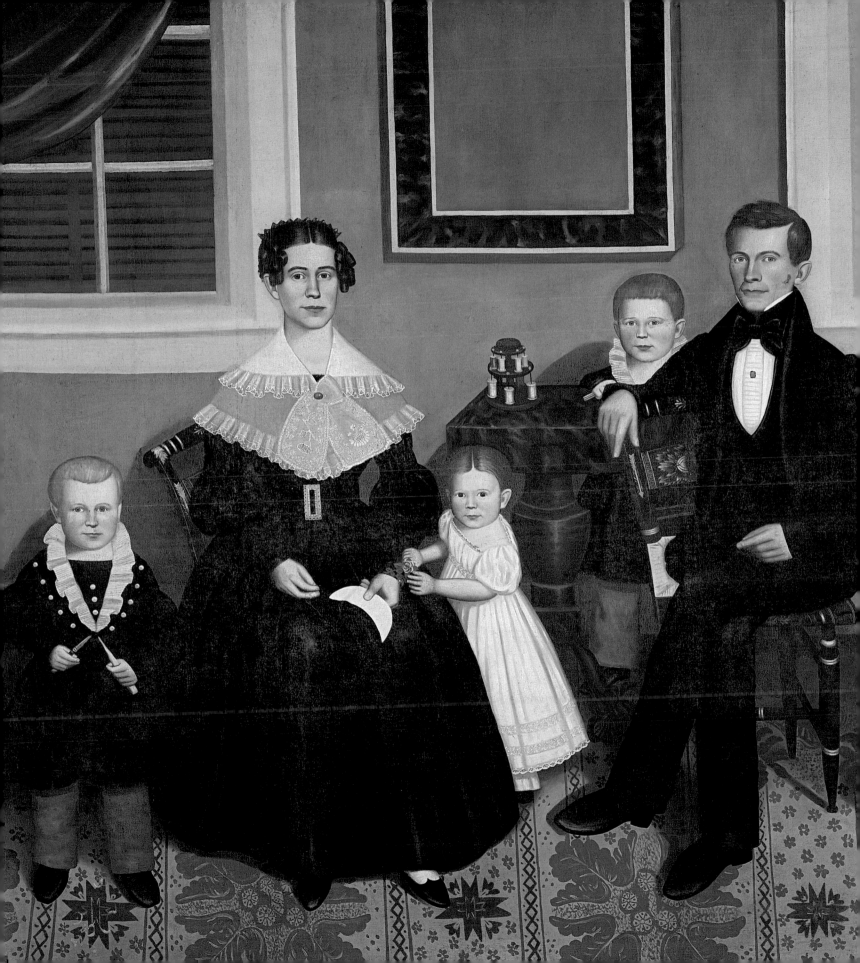

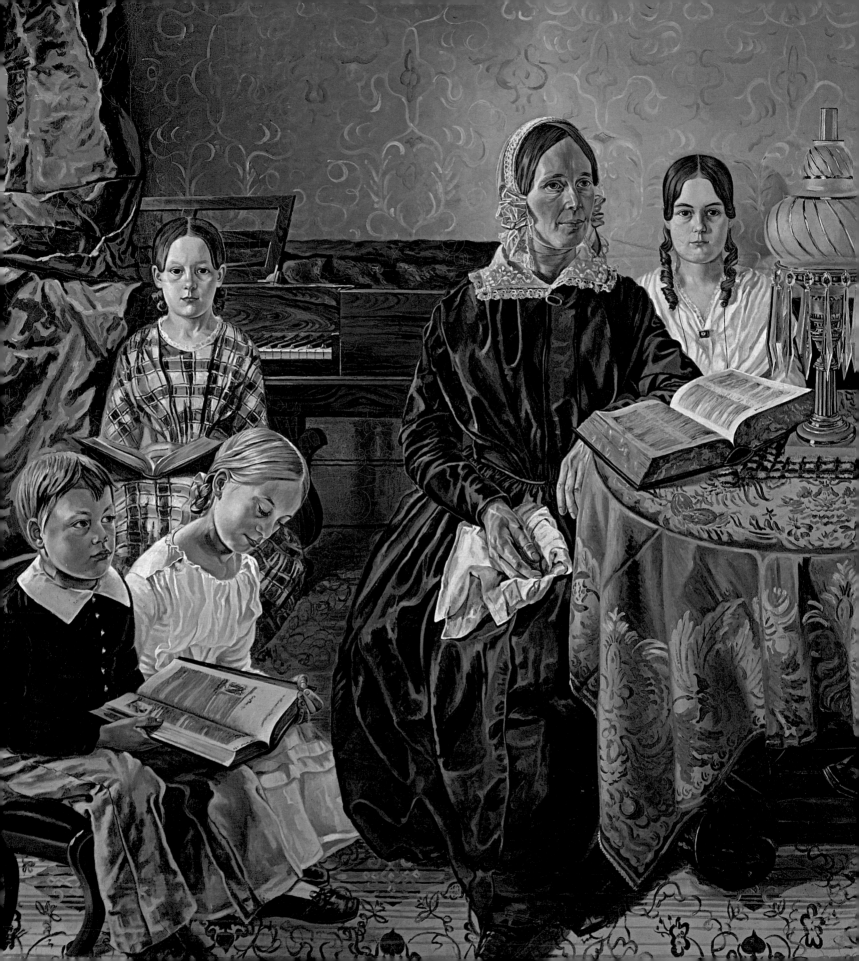

Henry F. Darby
(1829–1897)

The Reverend John Atwood and His Family, 1845
Oil on canvas
72⅛ x 96¼ in. (183.2 x 244.5 cm)
Gift of Maxim Karolik for the M. and M.
Karolik Collection of American Paintings,
1815–1865 62.269

Folk portraits are seldom monumental in scale, owing, perhaps, to the relatively modest means of their subjects. This one, however, is nearly life-sized, measuring roughly six by eight feet. Equally remarkable is the fact that the artist was only seventeen years old when he painted it. Henry Darby of Adams, Massachusetts, boarded with the Atwoods in Concord, New Hampshire, in the summer of 1845. He produced this portrait perhaps in payment for his lodging or perhaps to demonstrate his skill in rendering a variety of objects and personalities. The stern Atwoods are shown at their daily Bible study—John Atwood was a Baptist minister —in a setting that clearly demonstrates both their piety and their prosperity. Their walls are decorated with a fearsome, hand-colored print of *Samson Carrying Off the Gates of Gaza* and a mourning picture dedicated to a dead son. Their other furnishings are luxurious and up-to-date, including a newly invented type of oil-burning lamp hung with cut-glass prisms and, along the back wall, a piano.

The Atwoods' chiseled, hyper-real features reflect new standards of verisimilitude brought in by the invention of photography in 1839—and indeed, a comparison of the faces here with daguerreotypes of the Atwoods demonstrates Darby's skill at capturing likenesses. The portrait of the Atwoods is Darby's first known work and his greatest achievement. He went on to a career as both an Episcopal minister and an academic portrait painter, producing competent but undistinguished portraits in New York City and the Utica area for the next thirty years.

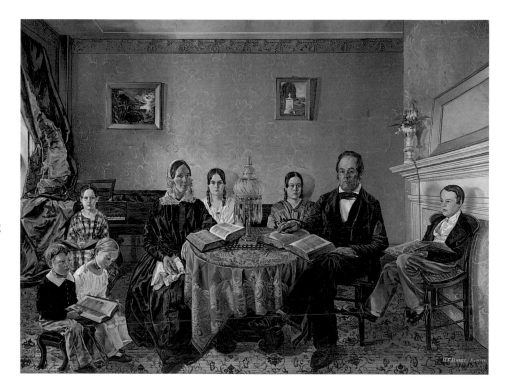

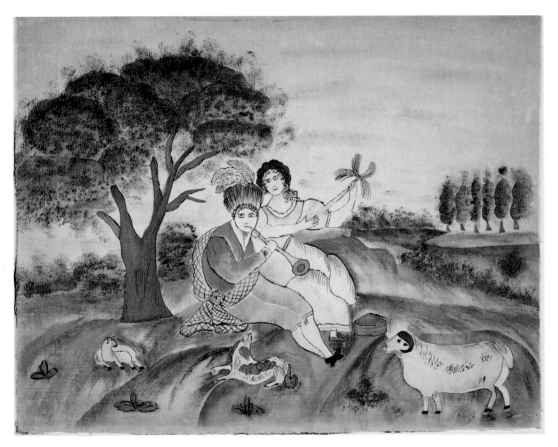

Unidentified artist

(active nineteenth century)

Shepherd and Shepherdess in Landscape, 1820–50
Pen, stencil, and watercolor on velvet
12⅜ x 15½ in. (31.4 x 39.4 cm)
The M. and M. Karolik Collection of
American Watercolors and Drawings,
1800–1875 62.136

There are a number of connections in folk
art between the textile arts of the eigh-
teenth century and painting in the nine-
teenth century. Rather than embroidering
with silk or wool, schoolgirls and house-
wives painted on silk or paper using
brushstrokes that resemble needlework,
and they stenciled pictures on cotton vel-
vet. The most common subjects were still
lifes, usually bouquets of flowers or bas-
kets of fruit. Rather originally, this artist
chose to paint a landscape with a young
couple, the boy playing a wind instru-
ment. The costumes and accessories sug-
gest that the design is based on a British
print from the Romantic era. Stencils were
used to create the general forms of the
trees, ground, and figures, with details
drawn in pen and ink and textures applied
with a stiff brush. A second painting on
velvet by the same hand depicts a boy and
girl gathering sticks of wood. Like the
musical couple, they have the staring eyes
that characterize the work of this rather
charming artist.

Mary Fleet

(1729–1796)

Piping Shepherd and Shepherdess, about 1745
Boston, Massachusetts
Linen, plain weave embroidered with wool
and silk
23½ x 22½ in. (59.5 x 57.5 cm)
Anonymous gift and Otis Norcross Fund
41.6

As with many young women who lived
during the seventeenth and eighteenth cen-
turies, needlework formed an important part
of Mary Fleet's education; she embroidered
this picture while a schoolgirl in colonial
Boston. Generally, embroidery skills were
first learned while completing a sampler. In
Boston, where there was a high concentra-
tion of wealth, many girls could afford the
time and the supplies to embroider more
ambitious projects, such as pictures and
coats of arms.

Shepherds and shepherdesses in pastoral
settings were commonly depicted on eigh-
teenth-century schoolgirl work in both Great
Britain and Boston, reflecting the artistic,
literary, and musical tastes of the period.
Virgil's *Eclogues*, which celebrate the happi-
ness and innocence of a shepherd's life, and
his *Georgics*, which extol the beauty of the
countryside, were often used in the educa-
tion of young men. Contemporary works
such as Alexander Pope's *Pastorals* and
Handel's operas echoed these themes.

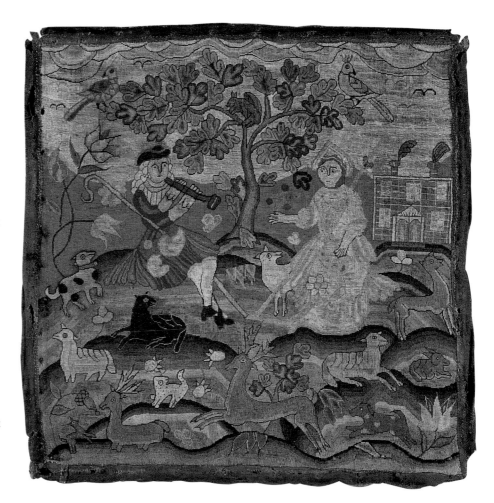

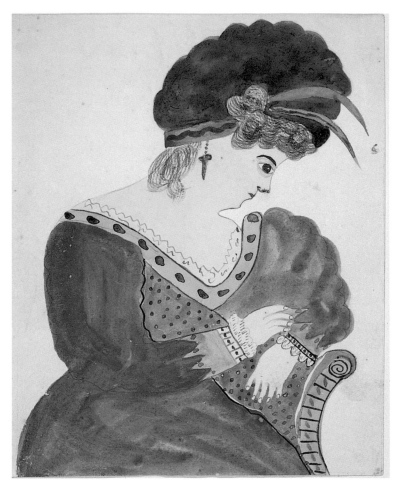

Mary Ann Willson

(active about 1800–1825)

Young Woman Wearing a Turban, about 1800–1825
Watercolor on paper
7⅞ x 6½ in. (20 x 16.5 cm)
The M. and M. Karolik Collection of
American Watercolors and Drawings,
1800–1875 56.456

Three Angel Heads, about 1800–1825
Watercolor on paper
8⅝ x 9³⁄₁₆ in. (21.9 x 23.3 cm)
The M. and M. Karolik Collection of
American Watercolors and Drawings,
1800–1875 50.3886

The Leave-Taking, about 1800–1825
Pen and watercolor on paper
13⁷⁄₁₆ x 10⁷⁄₁₆ in. (34.1 x 26.5 cm)
The M. and M. Karolik Collection of
American Watercolors and Drawings,
1800–1875 56.453

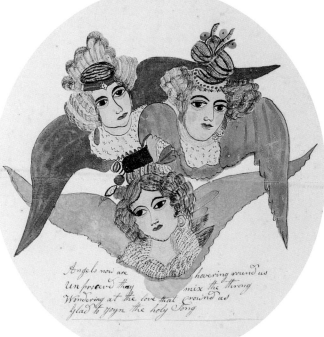

All that is known of Mary Ann Willson's life is contained in a mid-nineteenth-century letter, signed by "An Admirer of Art," that was discovered with twenty Willson watercolors in 1943. The letter explains that Miss Willson and Miss Brundage—"two maids [who] left their home in the East with a romantic attachment for each other"—bought a few acres and built a log cabin on the frontier, in Green County, New York. "One was the farmer and cultivated the land…the other made pictures which she sold to the farmers and others as rare and unique 'works of art.' Their paints or colors were of the simplest kind, berries, bricks and occasional 'store paint.'"

Among the earliest female folk artists working in watercolor, Willson is remarkable for her originality—compare the equally distinctive but very different style of her contemporary, Eunice Pinney (see page 96). Illustrated here are three of the ten Willson watercolors in the Museum's collection; all display the artist's characteristic expanses of bright, flat, firmly outlined color effectively contrasted with areas of diminutive patterning. The tearful *Leave-Taking* (at right) was probably based on a print; it is the kind of sentimental domestic image that was very popular in the eighteenth and early nineteenth centuries. Below the three angels (at left) are lines from a Methodist hymn, "O Thou God of My Salvation"; Willson may have belonged to this evangelical denomination that had many followers in New York State. The angels have multicolored wings, but their earrings, extravagant hairdos, large dark eyes, and strong brows are very similar to those in the image of the fashionable, turbaned lady.

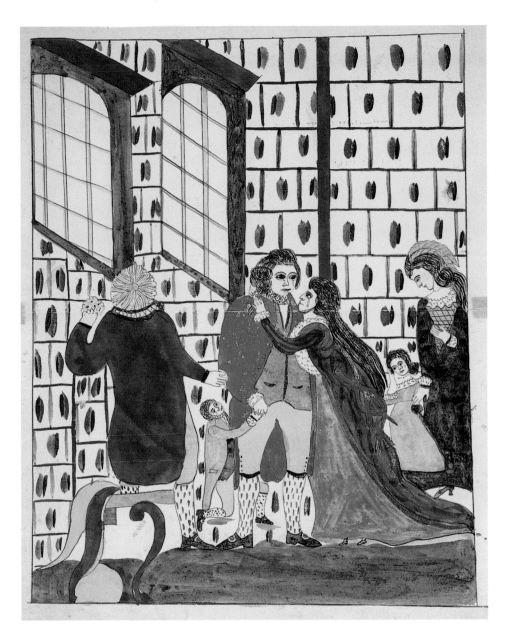

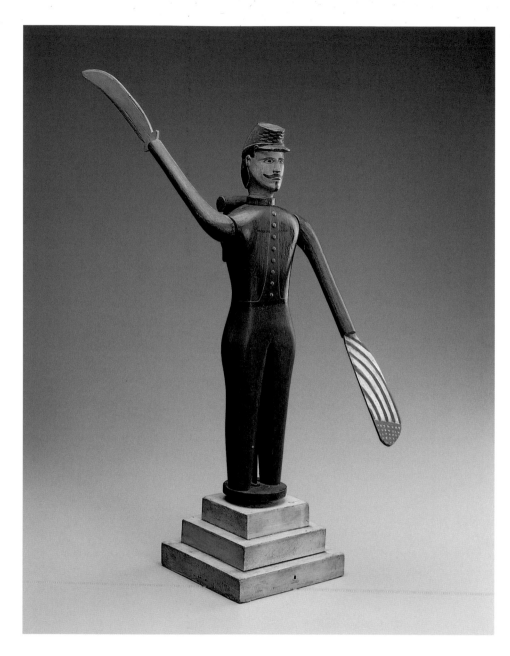

John Green Satterley

(died 1882)

Whirligig: Army Signalman, about 1865–70
Mount Vernon, New York
Painted wood
19 in. (48.3 cm); extension of arms approx.
27 in. (68.9 cm)
Gift of Maxim Karolik 58.1157

Whirligigs (or wind toys), like weather
vanes, indicate wind direction, and with
their rotating arms and other moving parts,
they also provide a rough indication of wind
velocity. By the nineteenth century, however,
when John Green Satterley crafted this exam-
ple, they were undoubtedly made primarily
for amusement and visual delight, and that
remains true today. Since many were placed
outside, few early examples have survived.

The swinging arms of Satterley's soldier
end in paddle-like forms resembling a
curved sword in his right hand and an
American flag in his left. His knapsack is let-
tered "14/SNY," probably for the 14th New
York Civil War regiment, who wore the dis-
tinctive red and blue uniform depicted on
this figure.

When this object was acquired for the
Karolik collection in the 1950s, its place of
origin was given as Mount Vernon, New
York, but its maker was unknown. Fortui-
tously, in 1983, a certain Constance M.
Higgins of Mount Vernon came across a
published illustration of the piece and
recognized it immediately as the work of
her great-grandfather. She owned two nearly
identical examples that had descended in her
family, one of which was inscribed "made by
J. G. Satterley." Like many folk artists, however,
Satterley, who ran a general store in Mount
Vernon, remains a largely unknown figure.

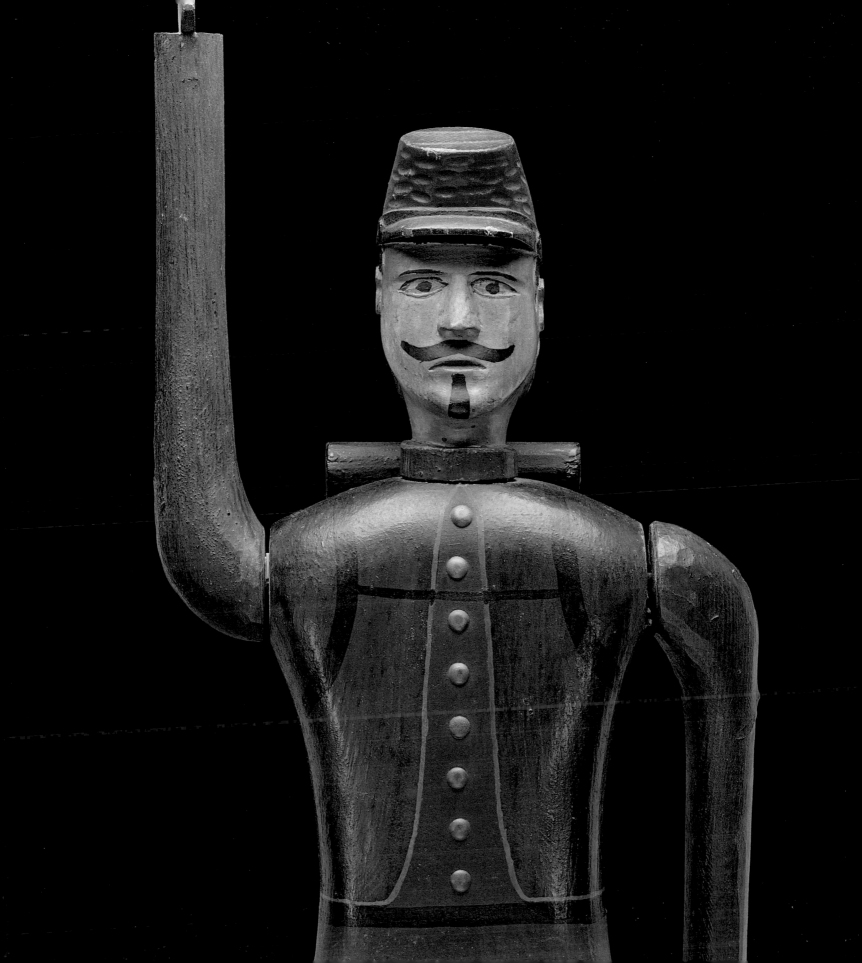

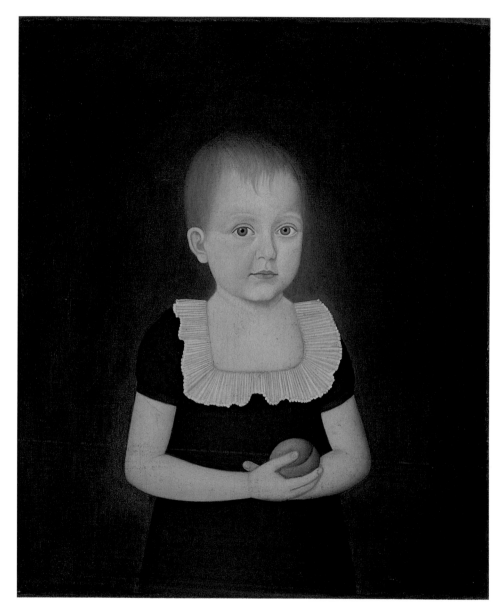

John Brewster, Jr.

(1766–1854)

Child with a Peach, about 1810
Oil on canvas
25 x 21 in. (63.5 x 53.3 cm)
Gift of Maxim Karolik for the M. and M.
Karolik Collection of American Paintings,
1815–1865 45.893

Ruth Whittier Shute

(1803–1882)

Sarah Ann Drew, about 1827
Graphite pencil and watercolor on paper
20¹⁄₁₆ x 15½ in. (51 x 39.4 cm)
The M. and M. Karolik Collection of
American Watercolors and Drawings,
1800–1875 60.446

The paintings on these two pages represent the poles of folk portraiture in early nineteenth-century America. The one by Brewster (at left), approaching academic levels of technical proficiency, presents a tender, sensitive, and convincing likeness. Shute's, on the other hand, appeals because of its bold color contrasts and striking design, which more than compensate for the anatomical inaccuracies and cartoon-like pose.

Sarah Ann Drew is one of the earliest works ascribed to Ruth Whittier Shute and was painted at about the time of her marriage to Dr. Samuel Shute, with whom she would collaborate on many later portraits. No information has been passed down about Sarah

Ann Drew except her name, which was inscribed at the upper left of the watercolor and then surrounded by Shute's characteristic streaky washes. Shute painted the child first and applied the background around her, giving the figure a cut-out, paper-doll quality. This quality is enhanced by the attention the artist paid to the charming orange-dotted dress, whose balloon sleeves and matching pantalettes peeking out beneath the hem must have pleased the wearer very much, despite her serious expression.

John Brewster, who was unable to speak or hear, was the son of a prominent doctor in Hampton, Connecticut. He was well educated and from an early age was encouraged to pursue his talent under the tutelage of local artists. It is frequently suggested that, because Brewster was unable to communicate in conventional ways, he was particularly sensitive to the nuances of personality. This unidentified child, solitary against a plain background, gazes at the viewer with large, soulful eyes. He holds a peach, a fruit whose season is brief in New England's cool climate and so may serve as a metaphor for the preciousness of childhood. Brewster's delicate paint handling and subdued palette—in contrast to the boldness of Shute's—enhance the serenity of his image and communicate the frailty and innocence of children.

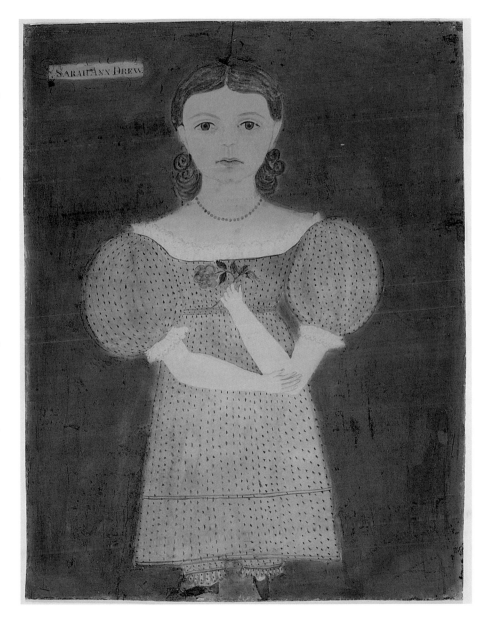

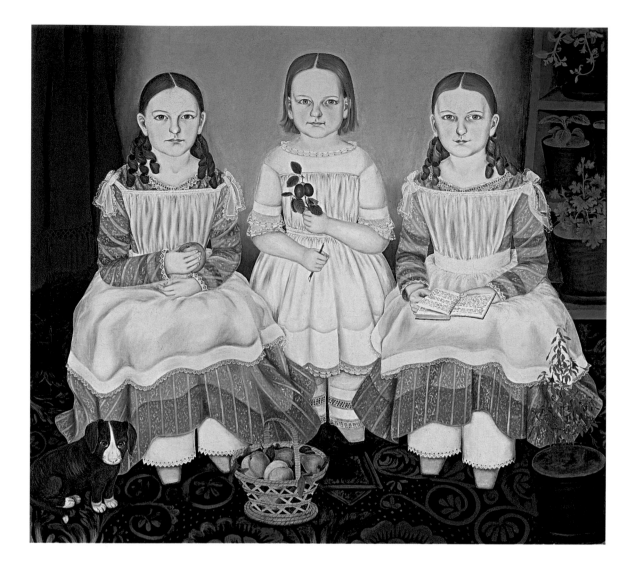

Susan Catherine Moore Waters

(1823–1900)

The Lincoln Children, 1845
Oil on canvas
45¼ x 50¼ in. (114.9 x 127.6 cm)
Juliana Cheney Edwards Collection, by
exchange 1981.438

Susan Waters took up painting as a profession about 1843, presumably to supplement the income of her ailing husband. Until 1845 she traveled around southern New York State, painting portraits of the local gentry

and their children. She then apparently ceased painting for about thirty years, returning to the public eye in 1876 at the Philadelphia Centennial Exposition with a painting entitled *Mallard Ducks and Pets of the Studio*.

The Lincoln Children is one of Waters's most accomplished portraits. Laura Eugenie, Sara, and Augusta Lincoln, ages nine, three, and seven respectively, were the youngest of twelve children of Otis Lincoln, a hotelkeeper in Newark Valley (near Binghamton), New York. Although the props in the painting—

the richly patterned rug, the fringed drape, the plant stand, and even the puppy with its neatly aligned white paws—were included to demonstrate the family's domestic comfort, many of them appear in other portraits by Waters. But few of those works are marked by the delicate drawing, pleasing color harmonies, and memorable characterizations that distinguish *The Lincoln Children*.

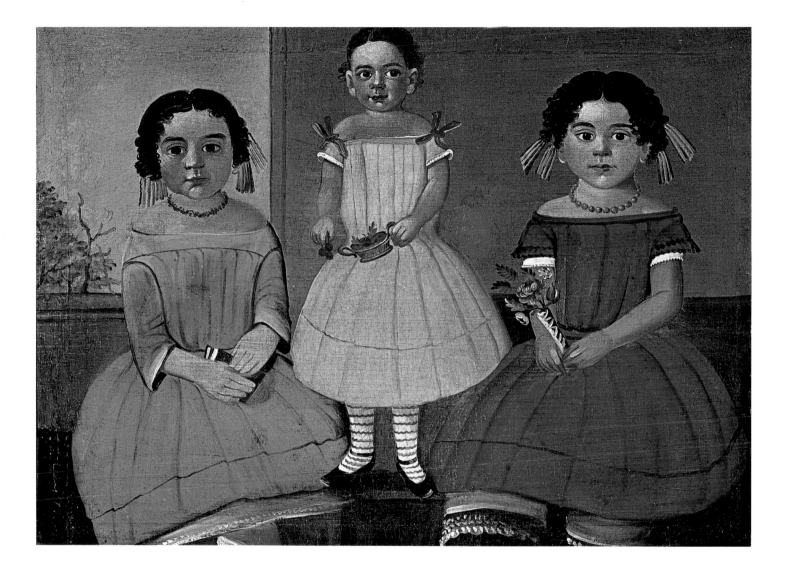

William Matthew Prior

(1806–1873)

Three Sisters of the Copeland Family, 1854
Oil on canvas
26⅞ x 36½ in. (68.3 x 92.7 cm)
Bequest of Martha C. Karolik for the M. and M. Karolik Collection of American Paintings, 1815–1865 48.467

By the mid-1850s, slavery had virtually disappeared in New England, and a small number of African-American families had begun to enter the middle class. Samuel Copeland of Chelsea, Massachusetts, was a second-hand clothing dealer and real-estate investor who by mid-century was sufficiently affluent to commission portraits of his children. As shown here, Eliza (about six years old), Nellie (about two), and Margaret (about four) sport dresses in the fashionable off-the-shoulder style; their hair ribbons and gold and coral necklaces are further testimony to their father's prosperity. The book Eliza holds advertises her education. Like the flowers and fruit held by the other two girls, the book is a common attribute in mid-nineteenth-century children's portraits, but it may have been a special point of pride here, for, despite his business acumen, Samuel Copeland was illiterate.

By hiring Prior to paint his children (a portrait by Prior of Copeland's son James is now in a private collection in New York), Copeland not only chose the leading local painter, but also one whose clientele included a number of African Americans. Prior, who ran a busy painting shop in East Boston, was a staunch abolitionist. In contrast to many contemporary images of blacks, which tended toward caricature, Prior's portraits were painted with sympathy and respect.

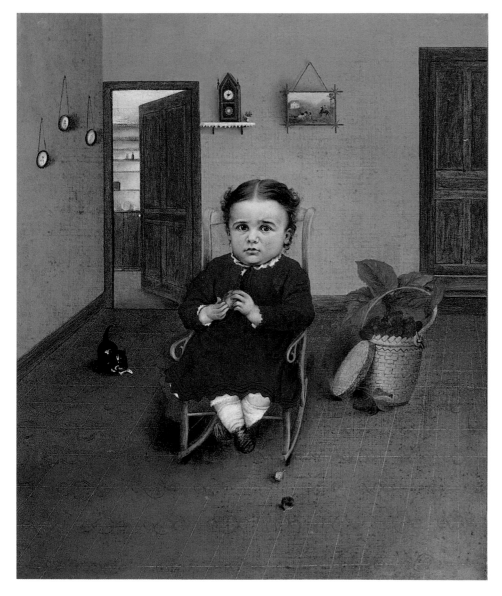

E. L. George

(active late nineteenth century)

Child in a Rocking Chair, 1876
Oil on canvas
15⅛ x 13 in. (38.4 x 33 cm)
Gift of Maxim Karolik for the M. and M.
Karolik Collection of American Paintings,
1815–1865 62.272

Puzzling, delightful, and slightly disconcerting, this small painting is signed "E. L. George," but nothing has yet been discovered about the artist. The extremely precise style of the image enhances its almost surreal quality. George was clearly concerned with perspective, striving to create a believable sense of recession into depth through the lines of the floor tiles and the diminutive size (compared to the child) of the cat, the clock, and the oval portraits on the bare wall. Other elements are more difficult to explain: the giant strawberries next to the child, for example, and the view through an open door of a cupboard or pantry with unexpectedly empty shelves. In contrast to the rather generalized rendering of most objects in the painting, the overlarge face of the child is highly specific both in its expression and in the careful delineation of features. This suggests the influence of photography, perhaps even a photographic source.

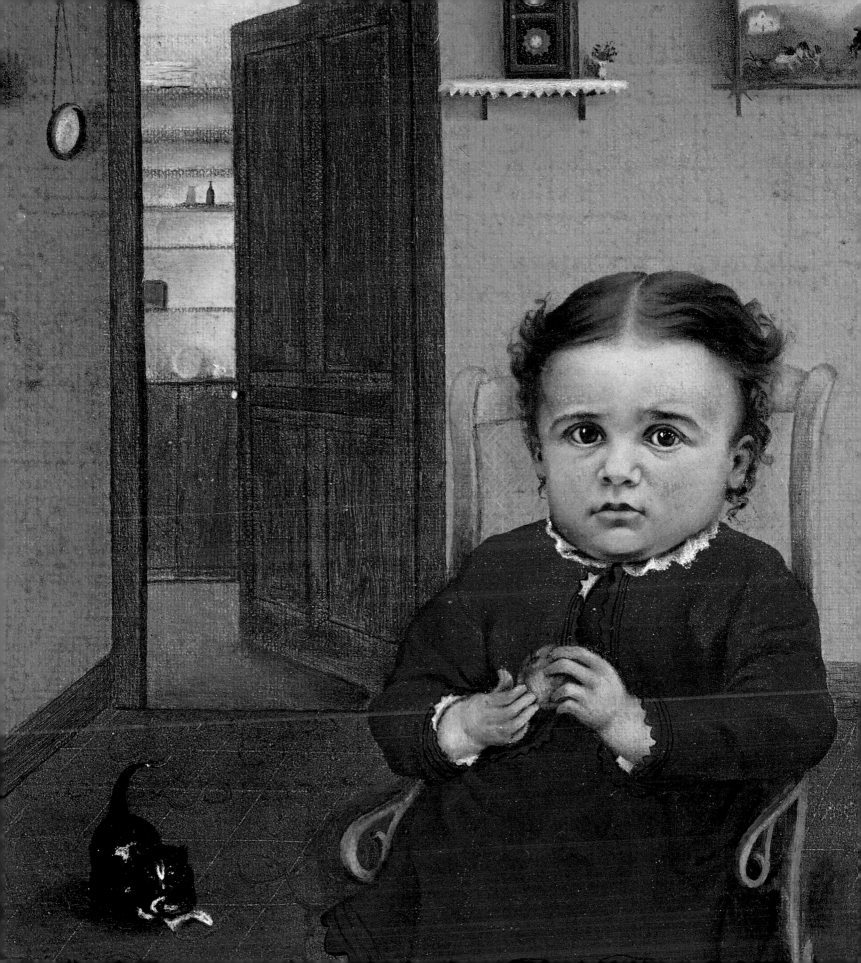

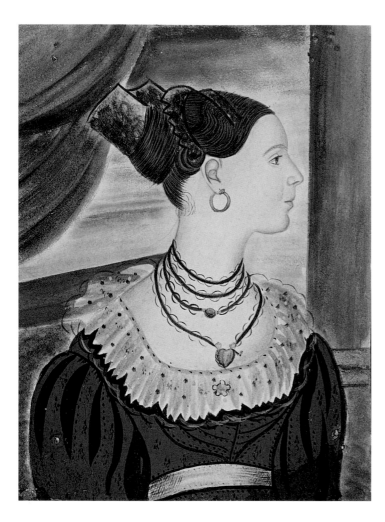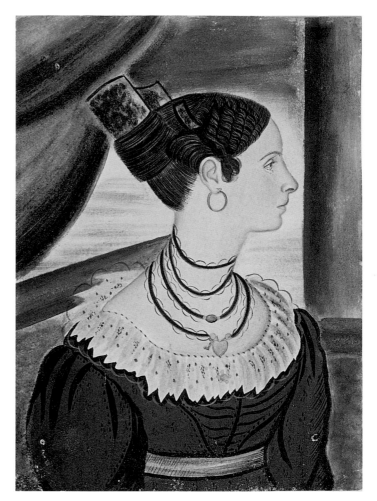

Edwin Plummer

(1802–1880)

The Goodwin Twins of Berwick, Maine, 1830–35
Watercolor over graphite pencil on paper
4¾ x 3⅝ in. (12.1 x 9.3 cm); 4⅞ x 3⁹⁄₁₆ in.
(12.4 x 10.1 cm)
The M. and M. Karolik Collection of
American Watercolors and Drawings,
1800–1875 52.1556, 52.1557

Portrait miniatures typify the portable, inexpensive predecessors to photographs. Despite his lack of schooling in art, Edwin Plummer demonstrates his uncanny ability to capture specific personality in this pair of twin sisters. Along with the many similarities of hair style, dress, and ornaments, his keen observation has netted him the subtle differences in the young women. One sister is brown-eyed, firm-chinned, and self-assured, while her twin is blue-eyed, soft-featured, and of a gentle aspect. Plummer was born in Haverhill, Massachusetts, and worked in Salem; after marrying a woman from Portland in 1830, he moved to southern Maine. In 1839 he went to Boston, where he worked as a portrait painter until the late 1840s.

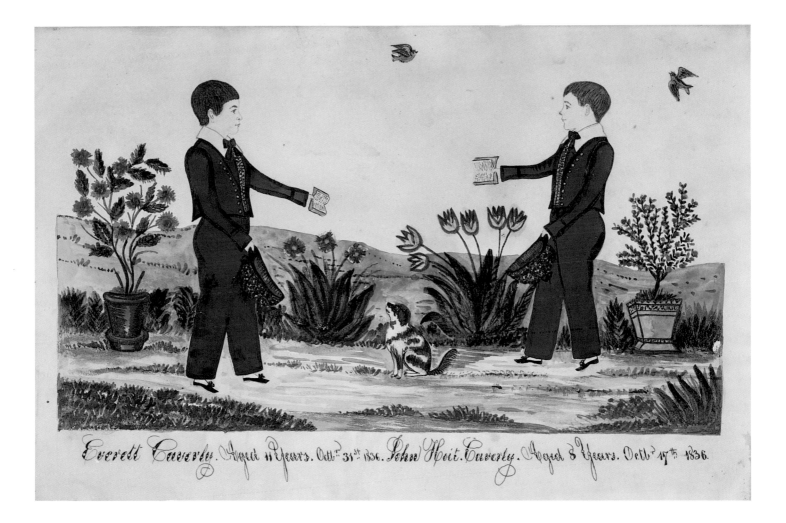

Everett Caverly. Aged 11 Years. Oct^r 31st 1836. John Hoit Caverly. Aged 8 Years. Oct^{br} 17th 1836.

Joseph H. Davis

(active 1832–1837)

The Caverly Brothers, 1836
Watercolor over graphite pencil on paper
8⅛ x 12⅛ in. (20.7 x 30.8 cm)
The M. and M. Karolik Collection of
American Watercolors and Drawings,
1800–1875 52.1608

Joseph H. Davis was an itinerant artist who painted in New Hampshire and Maine in the 1830s. Some 160 pictures in his distinctive style are known, a few of them signed "Left Hand Painter." He may have been the same man as a farmer called "Pine Hill Joe Davis" from Newfield, Maine, remembered as a wanderer who painted portraits for $1.50 apiece. Davis placed his simple, upright subjects, usually dressed in black, among vividly colored accessories that include painted furniture, patterned rugs, and bright flowers. He developed his own decorative calligraphy and used it to inscribe the sitters' names and ages at the bottom of the sheet. These two boys, Everett and John Hoit Caverly, were the eleven- and eight-year-old sons of Azariah Caverly, a farmer and militia man, whom Davis depicted in 1836 along with other members of the Caverly family of Strafford, New Hampshire. Owners of portraits by Davis appear to have enjoyed them for several generations, for most watercolors show signs of having been framed and hung on the wall.

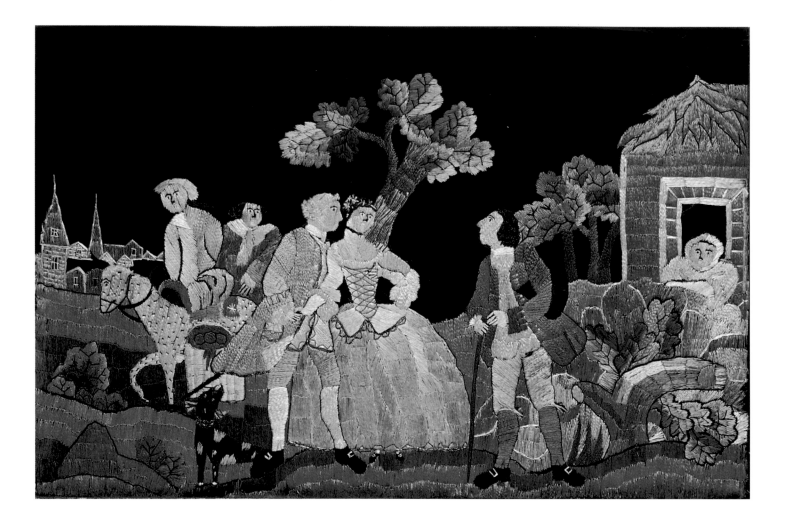

Love Rawlins Pickman

(1732–1809)

The Kiss Given (*Le baiser donné*), about 1745
Salem, Massachusetts
Silk satin embroidered with silk and metallic thread
16¼ x 22½ in. (41.2 x 57.2 cm)
The M. and M. Karolik Collection of
Eighteenth-Century American Arts 39.239

The Kiss Returned (*Le baiser rendu*), about 1745
Salem, Massachusetts
Silk satin embroidered with silk and metallic thread
15¾ x 21½ in. (40 x 54.6 cm)
The M. and M. Karolik Collection of
Eighteenth-Century American Arts 39.240

Sometime during the 1740s, Love Rawlins Pickman of Salem, Massachusetts, embroidered six pictures onto black silk. Four of the six are now in the Museum's collection. Two depict seascapes while the others show scenes from Jean de la Fontaine's bawdy French poem "The Kiss Returned," which were probably inspired by prints of Jean-Baptiste Pater's paintings, *Le baiser donné* and *Le baiser rendu*, engraved by P. Fillœul in Paris in 1733.

Engraved prints not only hung in colonial New England homes but were often used as sources in the composition of embroidered pictures. The artist who drew the underlying pattern for the Pickman embroideries must have been familiar with Fillœul's engravings.

It would be interesting to know if Love Pickman was as familiar with their literary source.

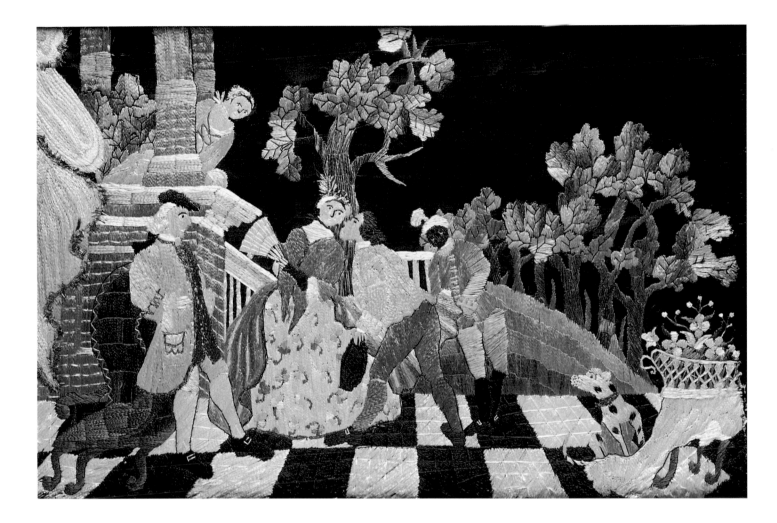

The Kiss Returned

A certain noble found Guillot's new bride
Much to his taste. "My man," said he, "I pray
You let me kiss your lovely wife. One day
I'll pay you back in kind!" Guillot replied:
"Monsieur may do his heart's desire with her."
Whereat the squire, with lusty buss, caresses
Poor Perronnelle, who, blushing, acquiesces.
Next week it happens that our gallant sir
Takes him a wife as well, and lets Guillot—
True to his word, indeed—come and bestow
A kiss in turn. The peasant, with much zest,
Acquits himself: many the "ah" and "oh"...
But then: "Damnation!" and he beats his breast.
"Since monsieur keeps his promise... Well, instead,
Why didn't he take my Perronnelle to bed?"

 —Jean de la Fontaine

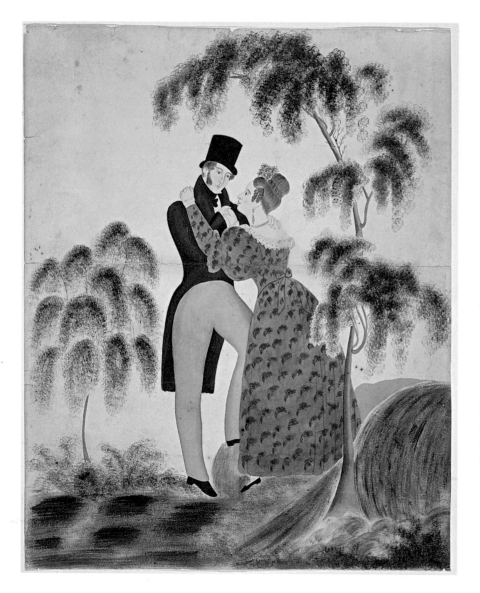

Unidentified artist

(active nineteenth century)

The Parting, about 1840
Watercolor and stencil on paper
11¹⁵⁄₁₆ x 9½ in. (30.3 x 24.2 cm)
The M. and M. Karolik Collection of American
Watercolors and Drawings, 1800–1875
58.930

The clean, precise outlines of the man and
woman embracing, and the smooth paint
surface of their garments, indicate that these
elements of the picture were made with the
aid of stencils. Stencils—often based on pro-
fessional work—enabled the amateur artist
to produce more sophisticated design ele-
ments while disguising weak draftsmanship.
The artist of *The Parting* added lively texture
to the woman's dress, the foliage, and the
foreground by dabbing with brushstrokes
of dry paint. The design may be based on a
lithograph such as one entitled *The Departure*,
printed by the D. W. Kellogg firm of
Hartford, Connecticut, in the 1830s. Similar
sentimental subjects were produced in large
numbers, both as single prints and in illus-
trated books.

Mary S. Chapin

(active nineteenth century)

Solitude, 1815–20
Watercolor over graphite pencil on
paper
15¼ x 13⅝ in. (38.7 x 34.6 cm)
The M. and M. Karolik Collection of
American Watercolors and Drawings,
1800–1875 60.469

This splendid example of schoolgirl art
is inscribed on the back of the sheet
with its title and the name of the young
woman who made it. The existence of
several other versions of the composi-
tion attests to its having been made
under the tutelage of a teacher, probably
in the Connecticut River Valley. Had
Mary Chapin been working ten or twen-
ty years earlier, her picture would more
likely have been stitched with silk thread
on fabric—in fact, both the technique
and the subject matter of this watercolor
derive from the embroidery tradition.
Mary Chapin executed much of her
watercolor picture in tiny brushstrokes
that resemble needlework's featherstitch,
fern stitch, and French knots, and at
the same time used broader strokes that
reflect British watercolor techniques
recently imported into America. The
woman daydreaming under a tree was
inspired by English embroideries depict-
ing Maria, the heroine of Laurence
Sterne's popular novel, *A Sentimental
Journey*, published in 1768.

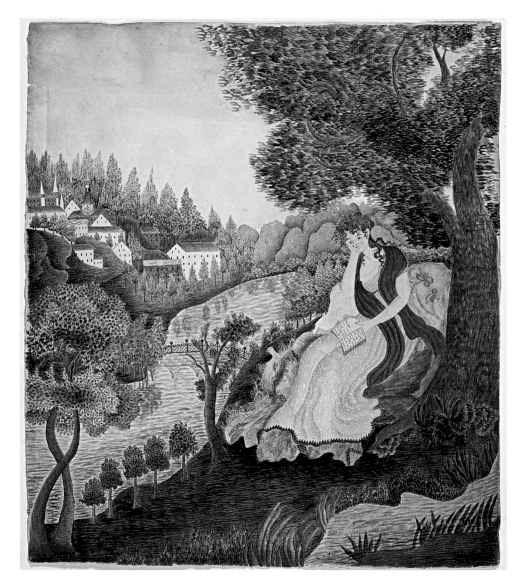

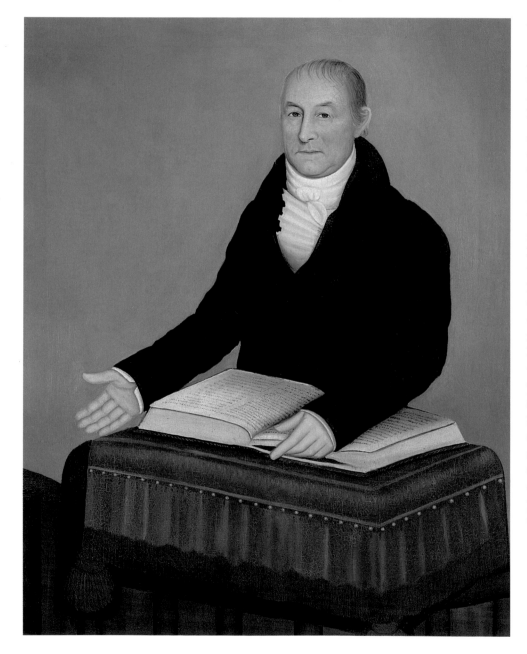

Ammi Phillips

(1788–1865)

Reverend Jonas Coe, about 1830
Oil on canvas
48⅛ x 38¼ in. (122.2 x 97.2 cm)
M. Theresa B. Hopkins Fund 1997.195

Ammi Phillips, an itinerant and self-trained artist, served a prosperous middle-class clientele in New York State and northwestern Connecticut. Reverend Coe, for nearly thirty years the pastor of the First Presbyterian Church in Troy, New York, was an important patron. This is one of Phillips's largest portraits of a single subject, and the scale of the figure and his dominating placement high in the picture space reflect Coe's standing in the community. Phillips depicted Coe at a worship service, reading from scripture. The minister's open right hand and the fingers of his left (marking the place of an earlier passage) suggest a pedantic preaching style; his dour expression augurs stern and lengthy sermons. But Phillips's decorative manner mediates the apparent severity of Coe's character: his stock is crisply painted, its pleats forming a captivating zigzag pattern, and the red drapery covering the pulpit cushion is punctuated by a staccato rhythm of gold tacks, heavy fringe, and enormous tassels.

A. Ellis

(active 1820s–1830s)

Mr. Tiffen of Kingston, New Hampshire, about 1820
Oil on panel
26⅛ x 18⅞ in. (66.4 x 47.9 cm)
Gift of Edgar William and Bernice Chrysler
Garbisch 69.1359

About fifteen portraits painted in the Waterville
area of central Maine and in southeastern New
Hampshire have been associated with A. Ellis,
about whom nothing is known except his
name. Lacking the skills of academic por-
traitists and even of many folk painters of his
era, in *Mr. Tiffen* Ellis nonetheless created an
image of remarkable elegance. Tiffen's high
collar, seemingly pasted to his chin and so giv-
ing it the shape of a rather tall teacup, was a
fashionable garment in the 1820s. His fitted
jacket, elaborate stock, and jeweled stickpin
describe a man of some wealth and style. At
the same time, the artist clearly had difficulties
with anatomy and modeling: Mr. Tiffen's body
is completely two-dimensional, casting no
shadow on the plain background; his hand,
tucked Napoleon-style into his jacket, is shape-
less. Furthermore, his features are disjointed:
his eyes and mouth are seen frontally, while his
nose (rendered with one line running continu-
ously from his eyebrow) is seen in profile.

Yet these very irregularities are what make
the portrait so appealing in our own day.
Pictures like this one, whose graphic strength,
striking color contrasts, and expressive distor-
tions resonated with the aims of modern Amer-
ican artists, contributed to the revival of interest
in folk art in the early twentieth century.

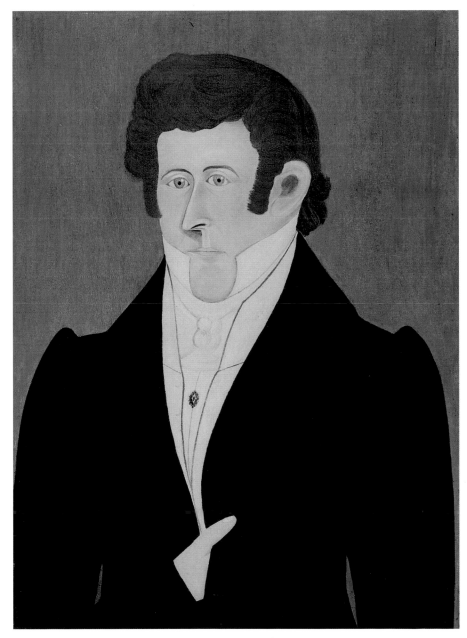

Birds
and Beasts

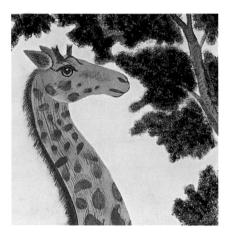

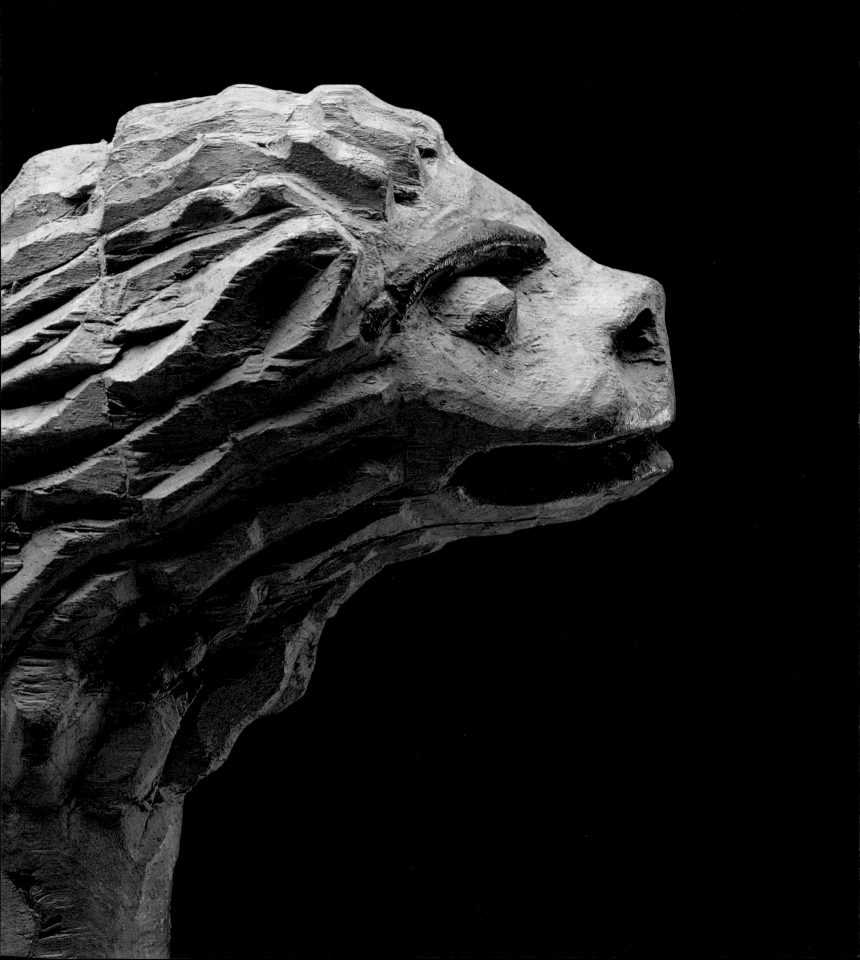

Wilhelm Schimmel

(1817–1890)

Lion, 1860–90
Cumberland County, Pennsylvania
Painted pine
6 x 8 x 3 in. (15.2 x 20.3 x 7.6 cm)
Gift of Maxim Karolik 60.501

Wilhelm Schimmel has long been recognized as one of the most colorful figures in American folk sculpture. Probably born in Germany, he lived in Cumberland County, Pennsylvania, and during the last half of the nineteenth century he seems to have spent much of his time as a whittler, bartering his work in exchange for strong drink. When he died in the Carlisle almshouse on August 3, 1890, the local newspaper referred to him as "'Old Schimmel' the German who for many years tramped through this and adjoining counties, making his headquarters in jails and almshouses.… His only occupation was carving heads of animals out of soft Pine wood. These he would sell for a few pennies each. He was apparently a man of very surly disposition." Schimmel's work was published in *Antiques* magazine in 1943 and quickly became a staple of folk art collections.

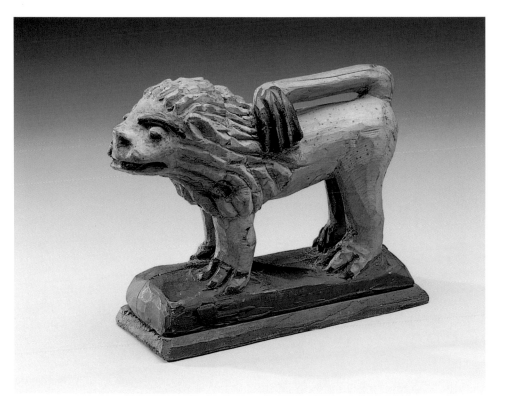

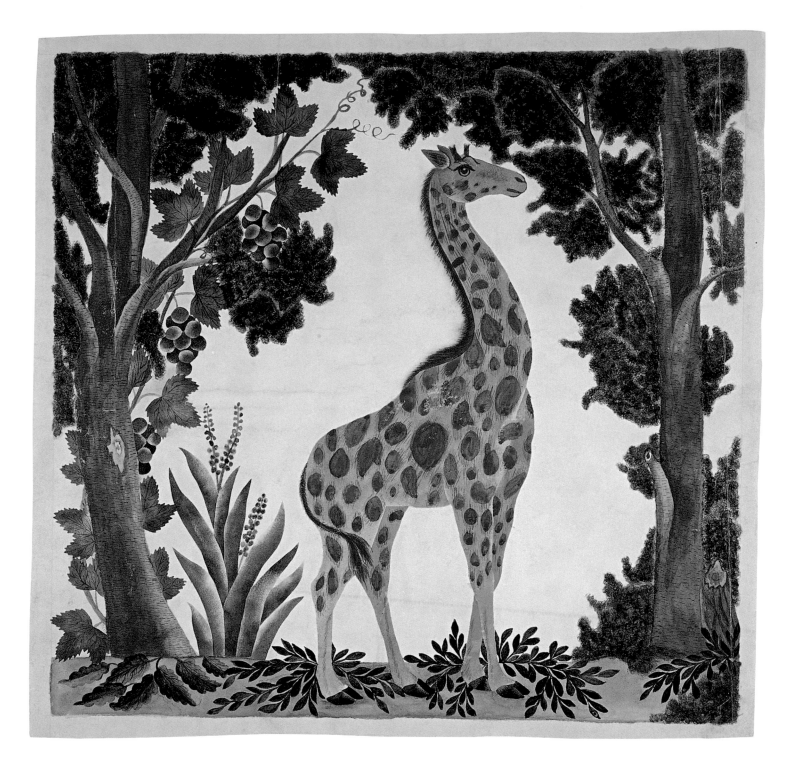

Unidentified artist

(active nineteenth century)

Giraffe, about 1836
Stencil and watercolor over graphite pencil
on paper
12⅛ x 12½ in. (30.8 x 31.8 cm)
The M. and M. Karolik Collection of
American Watercolors and Drawings,
1800–1875 52.1562

The gentle, voiceless giraffe appeals for its
unique shape and distinctly patterned hide as
well as for its exotic origins. The first giraffe
to survive in captivity was brought to France
in 1826, and that much-celebrated creature
was pictured in popular prints for many
years. It was either one of these popular
prints or an illustration from a natural his-
tory book that inspired the creator of this
watercolor. The meticulous work was most
likely done by a woman who used waxed-
paper stencils to produce the crisp outlines
of the giraffe, the grapevine, and a few other
parts of the composition, recalling the tech-
nique of appliquéd quilts. She then used a
round stencil brush to stipple tree foliage
and a fine brush to add linear details.

In the nineteenth century, pictures created
with the use of stencils were called theo-
rems, because the artist could "theorize" or
break down an existing design into its com-
ponent parts. With the resulting stencils, the
image—often a still life of fruit or flowers—
could be recreated in a methodical way. No
other version of this particular giraffe has
come to light, however, and this watercolor
appears to be unique.

Unidentified artist

(active nineteenth century)

Young Lion, about 1850–80
Pen and brown ink on paper
18 x 24 in. (45.7 x 61 cm)
The M. and M. Karolik Collection of American
Watercolors and Drawings, 1800–1875 60.1118

The maker of this drawing was probably a
young student practicing the scrolls and flour-
ishes characteristic of elegant handwriting at
the time. Using a steel pen and brown ink, the
unknown artist fashioned a jaunty lion with
an unruly mane and a mask-like face. The
source may have been an illustration, as yet
unidentified, in a copybook or contemporary
penmanship manual, or the drawing may sim-
ply have been the product of the artist's imagi-
nation. Whatever the source, it reflects the
importance placed in the mid-nineteenth cen-
tury on skill at penmanship, which was then
a staple in the educational curriculum.

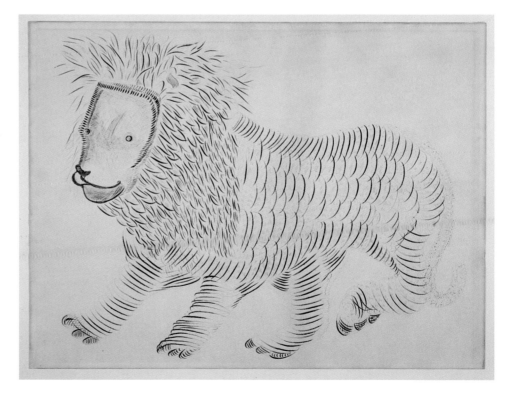

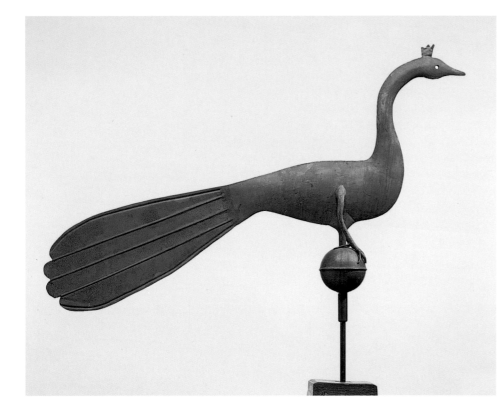

Unidentified artist

(active nineteenth century)

Peacock weather vane, about 1860–75
Eastern United States
Copper, painted gold; iron
19¾ x 33¾ in. (50.2 x 85.8 cm)
Gift of Maxim Karolik 54.1089

Weather vanes and weathercocks were once common features of the American land-scape. Many types of vanes were made from the seventeenth century onward, but few were as beautiful as this nineteenth-century example in the form of a peacock made of molded copper sheets joined together and then colored gold. Its flat, ribbed tail pro-vides a wide expanse perfectly designed to catch the wind, while its tall, S-curved neck arches gracefully from the body to its head, which sports a stylized crown imitating feathers.

Before about 1850, most weather vanes were one-of-a-kind, "handmade" objects, but after mid-century they began to be manufactured by companies specializing in their production. However, a great deal of handwork was still involved in their fabrica-tion and finishing, and thus they are almost always considered to be "folk art."

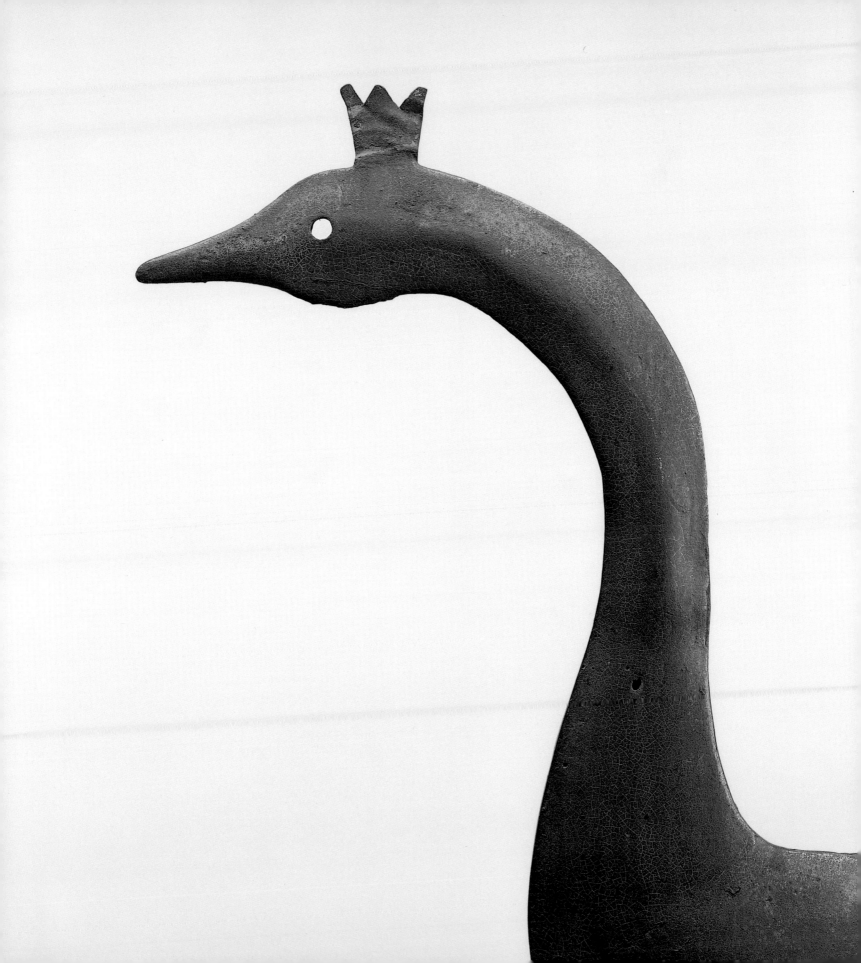

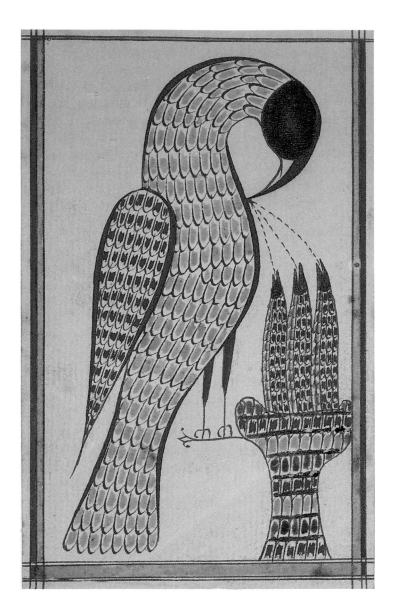

Unidentified artist

(active early nineteenth century)

Pelican Feeding Her Young, probably about 1800
Pen and watercolor on paper
4⅝ x 2¹⁵⁄₁₆ in. (11.7 x 7.5 cm)
The M. and M. Karolik Collection of
American Watercolors and Drawings,
1800–1875 56.760

First brought to America in the eighteenth
century by Germans settling in Pennsylvania,
decorative works on paper like this one were
also created in this country by local ministers
and schoolmasters until the 1830s, when
they were gradually replaced by printed doc-
uments. These frakturs (see also p. 98) were
often made to document births, baptisms,
marriages, and deaths; they were also pro-
duced as handwriting specimens, ornamental
bookplates, or as presentation pieces such as
Pelican Feeding Her Young. Artists might have given
these to others as tokens of love, friendship,
or encouragement, or as rewards to school-
children. Many works included poems or
religious inscriptions, and the owner of this
fraktur would likely have kept it in his or her
Bible in recognition of its pious message: the
motif of a pelican piercing her breast to feed
her young symbolizes charity and sacrifice
and was sometimes used as a metaphor for
Christ's sacrifice on the cross. This painting
may have been created by one of two artists
who taught at the Deep Run School in Bucks
County, Pennsylvania. Its bold, tapering ink
outline was typical of the work of both
Rudolph Landes and the painter known as
the "Brown Leaf Artist" (possibly David
Kulp).

Unidentified artist

(active late nineteenth century)

Foot scraper, about 1890–1900
Possibly Pennsylvania
Wrought iron
19½ x 13 in. (24.1 x 33 cm)
Gift of Maxim Karolik 58.1156

Before paved roads became common, boot or foot scrapers played an essential role in maintaining clean households. Most were made of iron, and they were usually simple in form, with a straight bar flanked by side supports embellished, for example, with scrolls. In this instance, however, the blacksmith has created a realistic yet fanciful "strutting chicken" that goes well beyond the demands of utility. With its beak open and with one foot raised and ready to march, this chicken has personality. The sheet iron was cut to form the realistic head at one end (complete with pierced eye) and the three flaring tail feathers at the other, while the legs with their carefully articulated feet were fashioned separately and riveted to the body. The object was nailed to a front doorstep or to the pavement through the other foot; this unusual feature suggests that this chicken may have been more ornamental than functional. Although reminiscent of eighteenth-century weathercocks, this foot scraper probably dates to the late nineteenth century. Of unknown origin, it may be from Pennsylvania, where ornamental ironwork was popular.

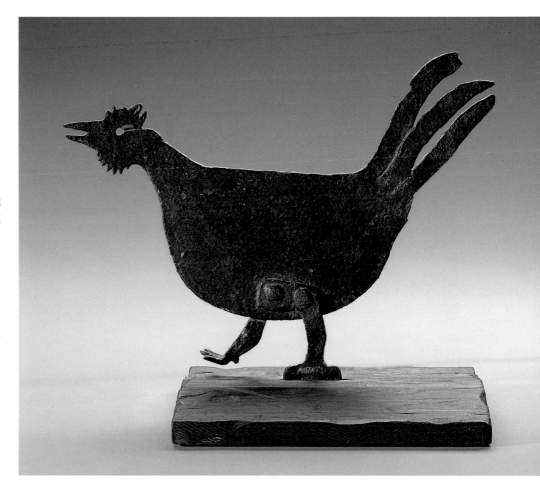

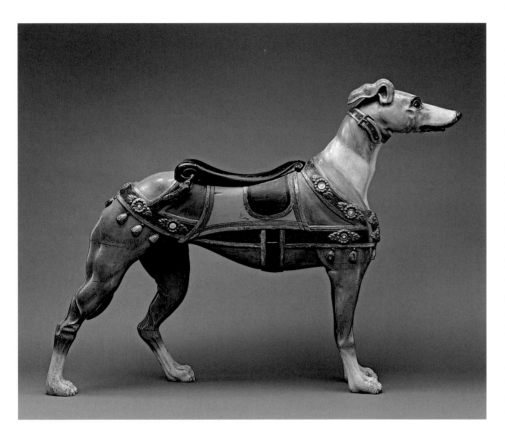

Charles Looff

(1852–1918)

Greyhound carousel figure, about 1905
Riverside, Rhode Island
Painted wood, glass
54 x 15 x 73 in. (137.2 x 38.1 x 185.4 cm)
Gift of Claire M. and Robert N. Ganz
1992.267

Although carousels had delighted European children from the seventeenth century, the first American carousel patent was not issued until 1850. Charles Looff, whose name is stamped on this greyhound's belly, was one of the most famous makers of carousel figures. A German immigrant and a furniture carver by trade, Looff settled in Brooklyn, New York, in 1870. Five years later he turned his hobby into a business, carving and painting a menagerie for his first carousel, at Coney Island. Over the years he established three successful factories, in New York, Rhode Island, and California. Looff's repertoire ranged from buffaloes to teddy bears to storks; he created several greyhounds which, according to tradition, were modeled after his own pets.

Greyhounds are unusual among carousel animals. This handsome example, with glass eyes and ears rippled by wind, is a "stander," one of the more highly decorated figures that were placed on a carousel's outer ring. It is not known to which carousel it once belonged, but the dog was given to Dr. Robert Ganz, a Boston pediatrician, by a former patient who had grown up and joined the circus. When the owners presented the dog to the MFA, it was dark brown and covered with thick varnish. Beneath the varnish were at least fourteen layers of paint; carousel figures, constantly exposed to the elements, required repainting about every three years. Museum conservators have now restored the greyhound's original painted surface punctuated by cut-glass ornaments.

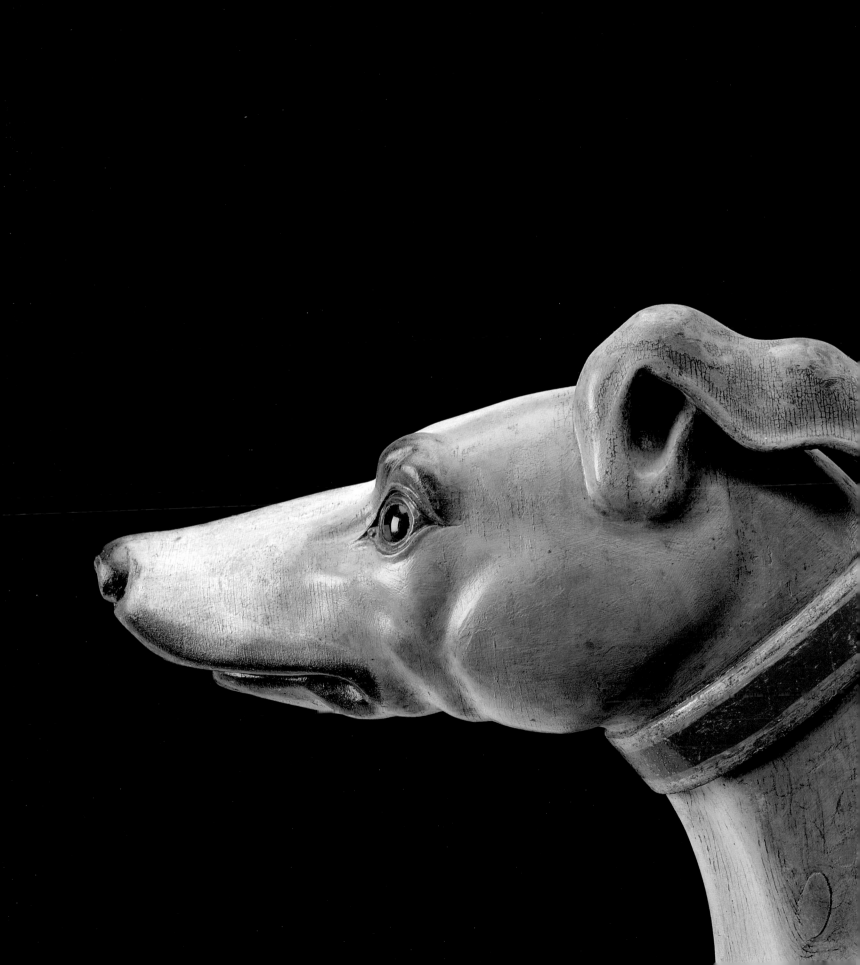

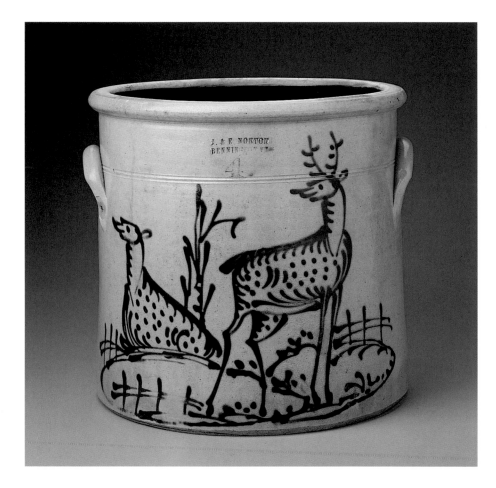

J. and E. Norton Pottery

(active 1850–1859)
decorated by John Hilfinger (1826–1859)

Pot, about 1850
Bennington, Vermont
Stoneware with cobalt-blue decoration
12 x 13 in. (30.5 x 33 cm)
Gift of Mrs. Lloyd E. Hawes in memory of
Nina Fletcher Little 1993.546

Bennington salt-glazed stoneware with fanciful cobalt-blue decoration has long been of interest to collectors of Americana. This large, four-gallon pot produced by the firm of Julius and Edward Norton was used for foodstuffs. It bears the pottery's mark and is embellished with a spotted stag and doe amidst fences and foliage. Recent scholarship has attributed this freely painted decoration to the hand of John Hilfinger, a German-immigrant itinerant artist who decorated the products of several potteries in Massachusetts, Vermont, and New York State in the mid-nineteenth century. His artistry elevates an otherwise purely functional object into a significant work of folk art. It was given to the Museum in 1993 by Vivian Hawes, a noted ceramics collector and scholar, in memory of Nina Fletcher Little, the doyenne of New England folk art collectors.

N. W. Wineland

(active nineteenth century)

Group of Merino Sheep, about 1879
Black and colored chalk on paper
15¾ x 22⅞ in. (40 x 58.1 cm)
The M. and M. Karolik Collection of
American Watercolors and Drawings,
1800–1875 56.744

American folk art includes many "portraits" of prize livestock; this one appears to be a family portrait, with ram, ewe, and lamb. In a composition that emphasizes the rhythmic play of lines on trees, rocks, and sheep, the artist has both accurately rendered his subjects and created a proud image of rural prosperity and contentment. On a stone is inscribed: "Drawn with pencil by N. W. Wineland, Centerburg, Ohio," a rural village in the center of the state. Nothing further is known of the artist; the drawing is dated by the watermark on the paper.

Spain was the original home of Merino sheep, famous for their fine, heavy fleece. After they came to America in the early nineteenth century, some Merinos were bred with the loose, wrinkled skin seen here, in order to increase the wool growing area. The sheep appear dark because their wool had a high content of oil that readily picked up dirt, turning the outside tip of the white wool black.

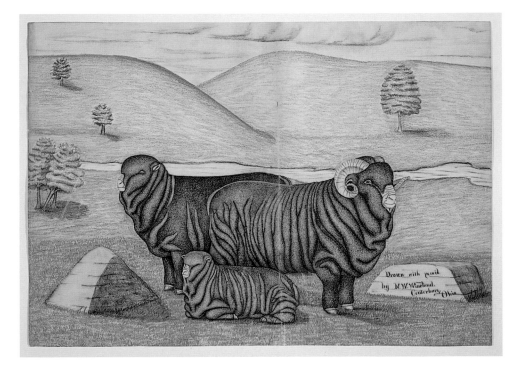

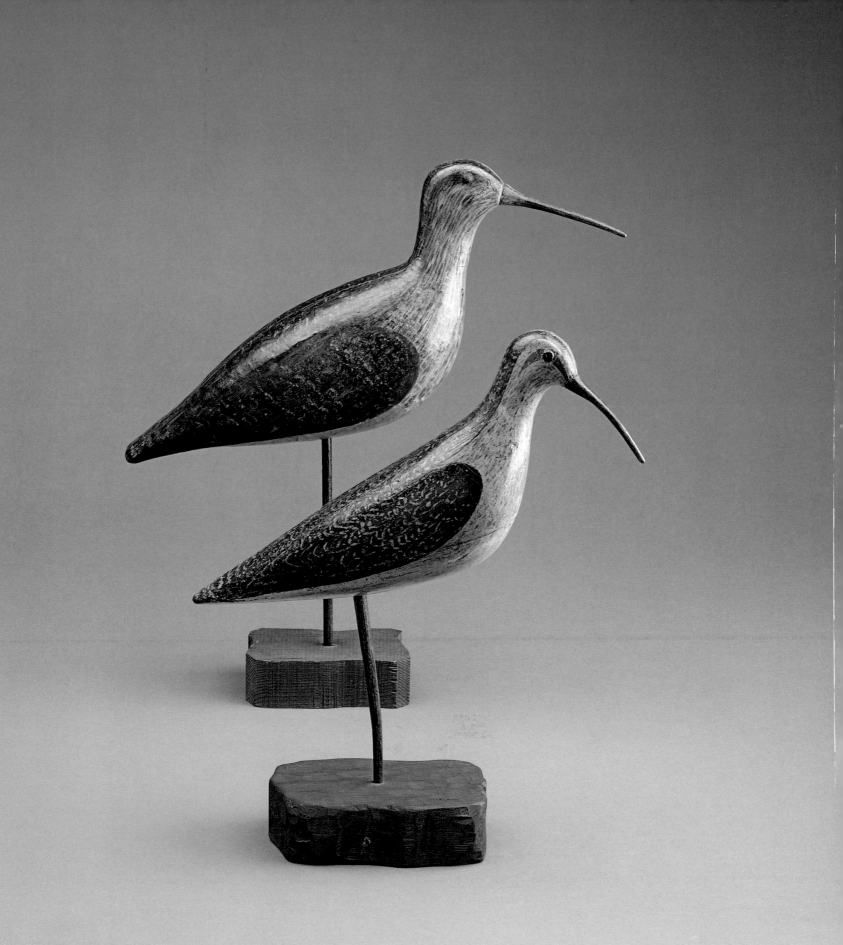

Unidentified artist

(active late nineteenth century)

Sickle-bill curlew, about 1890–1900
Probably New England
Papier maché
13¾ x 13½ in. (34.9 x 34.3 cm)
Gift of Maxim Karolik 60.481

Unidentified artist

(active late nineteenth–early twentieth century)

Hudsonian curlew, about 1900
Chatham, Massachusetts
Painted wood
11 x 12 in. (27.9 x 30.5 cm)
Gift of Maxim Karolik 60.482

Attributed to
Augustus Aaron "Gus" Wilson

(1864–1950)

Red-breasted merganser drake, about 1910
Monhegan Island, Maine
Painted wood
8 x 19 in. (20.3 x 48.3 cm)
Gift of Maxim Karolik 58.1159

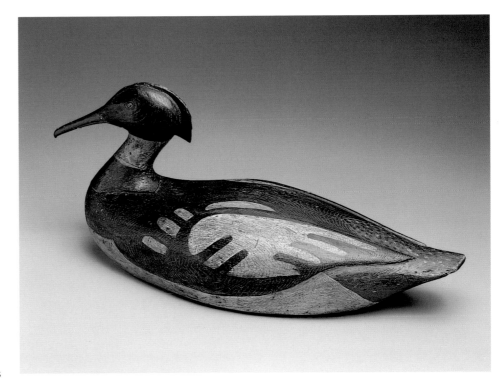

The art of decoy making was born in America. A thousand years ago, native Americans attracted wildfowl with rushes twisted into birdlike shapes. The practice was adopted by European settlers and reached its peak in the mid-nineteenth century when commercial market gunners, using large groups of decoys called rigs, decimated the huge flocks of birds that passed, on a completely predictable schedule, over America's transcontinental migratory flyways.

Thousands of individuals and dozens of small factories produced decoys. The requirements were few but essential: decoys had to be inexpensive and durable, and in order to attract birds flying far overhead, they had to mimic that bird in general but key ways: the set of the head and angle of the neck; the shape of the bill; the position of the bird as it rides in the water. Realistically carved and painted details were unnecessary, as a smooth shape and a few strategically placed strokes of color read best from a distance.

Most decoys are serviceable blocks of wood. A few, created by carvers whose gifts drew them beyond function, are works of art. Handsome objects with sleek forms and bold decoration, they also capture the essence of the birds they represent.

Of the examples pictured here, the merganser drake (above) is attributed to Gus Wilson, a lighthouse keeper who carved an estimated five thousand decoys for sale to hunters along the southeastern coast of Maine. The curlews are stickups, shorebird decoys with a leg-like stick that was thrust into the ground. The larger one behind is made of papier maché, probably from newspapers or brown bags; decoys were also constructed of cork, tin, and leather.

Unidentified artist

(active mid-nineteenth century)

Chest with drawers, about 1840–60
Possibly New York State
Painted pine
28½ x 43½ 18½ in. (72.4 x 110.5 x 47 cm)
Gift of a Friend of the Department of
American Decorative Arts and Sculpture and
Frank B. Bemis Fund 1982.400

Like much folk art, this chest presents a challenge in terms of determining its origin and understanding its meaning. With a history in York County, Pennsylvania, it was acquired by the MFA as an example of a Pennsylvania German dower chest. However, its construction, hardware, and other aspects suggest that it was more likely made in the Northeast, perhaps in New York State. Its painted decoration—covering every available surface, even including the lid and side of the interior till—is likewise something of an enigma. While the trailing vine on the top and the paired parrots on each side panel seem purely decorative, the precise meaning of the scene depicted on the front remains unclear. It shows a man facing a woman, each holding a pole with a flag containing what might be emblems of industry (tools for the man) and domesticity (hearts and flowers for the woman), and each with a horse and black groom at the side. The initials MF are probably those of the original owner, and this may well have been a dower chest.

What is clear is that the color of the paint here has changed dramatically. Scientific analysis reveals that the bodies of the parrots, some of the tree branches, and other details that now appear to be black were originally green. Similarly, the ground color on the drawers—once a bright salmon—has turned yellow over time. Thus, although what we see today has survived in excellent condition, chemical reactions caused by the inherent nature of the original paints have given the chest a very different appearance from what its maker intended.

Land
and Sea

Unidentified artist

(active about 1875–1900)

Running Before the Storm, about 1880
Oil on canvas
24 x 36¼ in. (61 x 92.1 cm)
Gift of Martha C. Karolik for the M. and M.
Karolik Collection of American Paintings,
1815–1865 46.851

At once melodramatic and comic, *Running Before the Storm* shows a sudden thunderstorm on an unidentified and quite possibly fictional farm by a lake. Lightning crackles through an ominous sky, horses rear and buck nervously, laundry flaps wildly on the line, and two children struggle against the wind in hopes of getting home before the deluge. Nineteenth-century painters often used storm scenes to dramatize the ineffectualness of humankind before the sublime, often overwhelming, power of nature. But here, the solemnity of that message is undercut by the anecdote in the center foreground. The puny farmer, improbably running with both arms extended, chases after his hat, assisted by his dog.

Running Before the Storm is a close copy of an engraving entitled *Thunderstorm* that appeared in Professor Herbert W. Morris's *Work-Days of God; or, Science and the Bible* (1877). But, like many folk artists, the painter of this lively scene deviated expressively from his sources. Just as he took the energy from romantic paintings of storms but minimized their deeper meaning, so in borrowing from the engraving, he seems to have been unaffected by the book's attempt to reconcile theology and science. Rather, the print provided the compositional backdrop for the artist's love of story telling; his penchant for strong, decorative color; and for the sense of motion created by his short, repeating brushstrokes that convey the excitement of the storm.

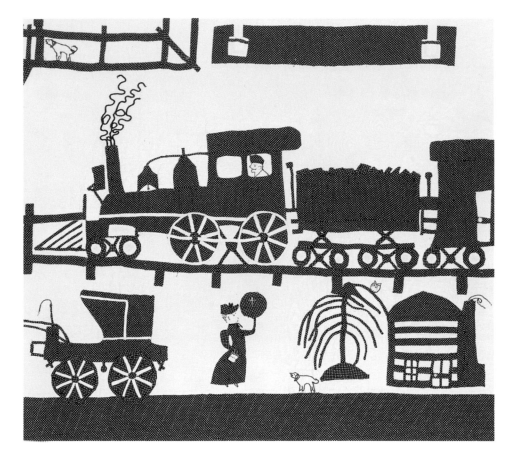

Unidentified artist

(active late nineteenth century)

Pictorial quilt, 1888
Possibly Peru, Indiana
Cotton plain weave; pieced, appliquéd,
embroidered, and quilted
77½ x 73 in. (196.9 x 187.3 cm)
Otis Norcross Fund and Arthur Tracy Cabot
Fund 2000.672

The history of quilts in the West can be
traced back to the late sixteenth century,
when Europeans imported embroidered
and quilted textiles from India for use as
bed covers. By the 1880s, however, pictorial
quilts were often made for decorative rather
than functional purposes. A quilt like this
one would never have been slept under, but
rather displayed for visual enjoyment.

This unique quilt, with its carefully depict-
ed buildings, railroad tracks, and trains,
along with its keenly observed people and
animals, is a wonderful example of American
folk art and indicates a fascination with a
world increasingly on the move. By 1888,
railroads stretched across the United States
and steamed into many small towns bring-
ing an end to rural isolation. When the quilt
entered the Museum's collection it was said
by the dealer to have been made in Peru,
Indiana. The initials "E.R." may refer to the
maker of the quilt, its recipient, or to the
Erie Railroad which reached Peru during the
late nineteenth century.

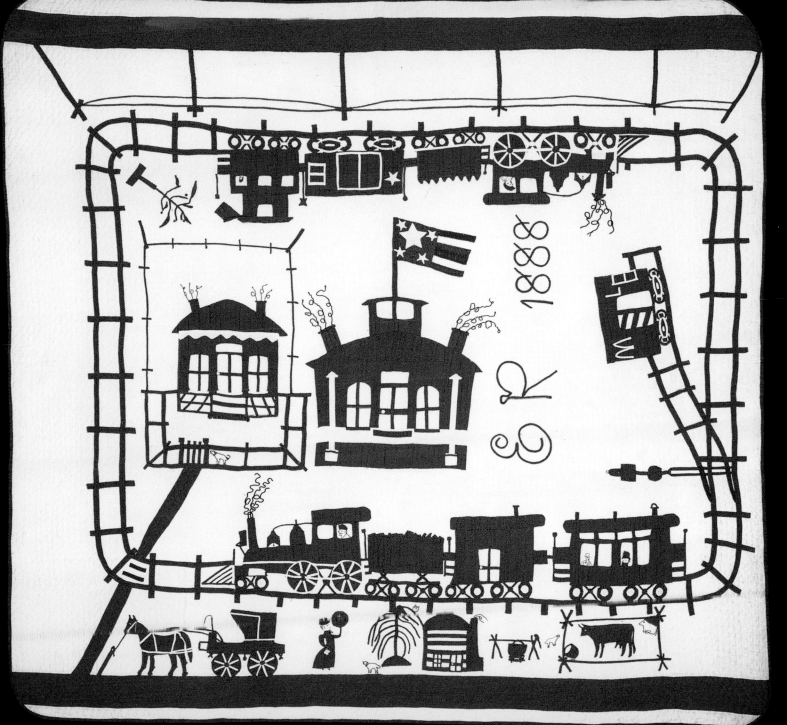

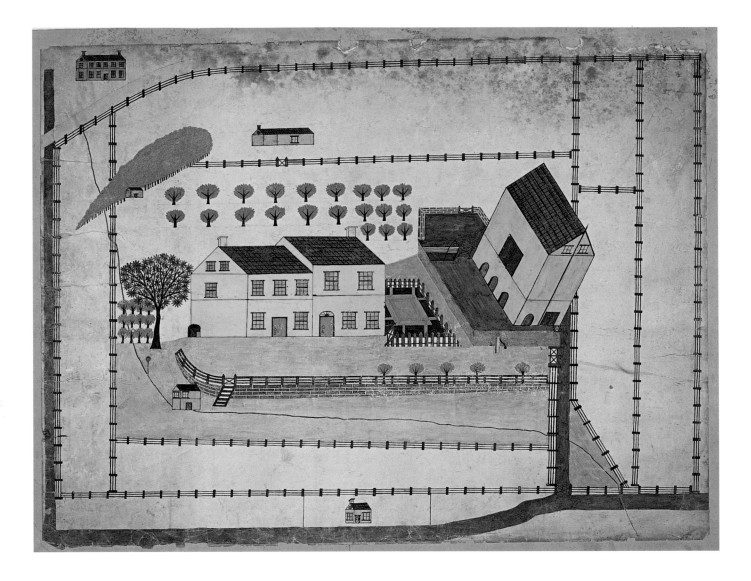

Unidentified artist

(active nineteenth century)

Pennsylvania Farmstead with Many Fences, 1840–50
Pen and watercolor on paper
18 x 23⅞ in. (45.7 x 60.6 cm)
The M. and M. Karolik Collection of
American Watercolors and Drawings,
1800–1875 56.740

In an agricultural economy, such as the United States in the mid-nineteenth century, a farm was its owner's fortune. Occasionally the farmer had a portrait of his holdings painted. This drawing from Pennsylvania depicts a spacious, well-kept property consisting of a pleasant dwelling adjacent to a neatly fenced kitchen garden and a tall barn and surrounded by a grove of trees, a fruit orchard, a stream, several outbuildings, and a number of fenced fields. The gifted artist

employed multiple viewpoints that described each structure with clarity and above all produced a pleasing design. Many of the same stylistic elements appear in a drawing of a farm with a barn inscribed "Built by C. G. A. Horst, 1847"; this latter drawing, sold at auction in 1984, is signed by a certain Charles H. Wolf.

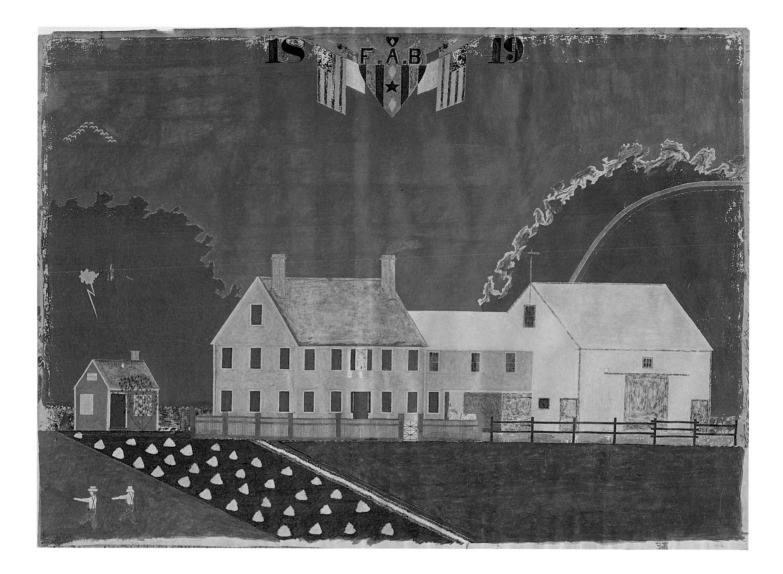

Unidentified artist

(active nineteenth century)

Farmstead in Passing Storm, 1849
Opaque watercolor on paper
9¹⁵⁄₁₆ x 13⅞ in. (24.8 x 34.3 cm)
The M. and M. Karolik Collection of
American Watercolors and Drawings,
1800–1875 56.433

More conventional in its perspective than
Pennsylvania Farmstead with Many Fences illustrated
on the preceding page, this drawing shows
brightly colored farm buildings silhouetted
against a dark, dramatic sky that contains a
flight of birds, a bolt of lightning, and an
arching rainbow. In contrast to the rich
brown earth of the garden, rows of white
protective caps cover delicate plants. At the
top of the picture is a coat of arms flanked
by American flags and the date 1849. The
meaning of the initials F. A. B. has yet to be
discovered.

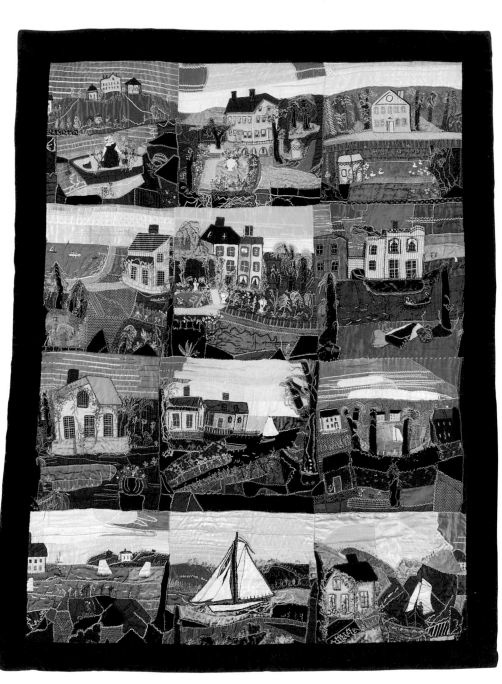

Celestine Bacheller

(1839–about 1922)

Crazy quilt, about 1875–1900
Wyoma, Massachusetts
Silk, pieced and embroidered
74 x 57 in. (188.7 x 144.6 cm)
Gift of Mr. and Mrs. Edward J. Healy in
memory of Mrs. Charles O'Malley 63.655

A craze for crazies developed during the last quarter of the nineteenth century. Crazy quilts, characterized by irregular, seemingly random patches embroidered with a variety of decorative stitches, were often worked by women as showpieces and had a decorative rather than functional purpose. The interest in them accelerated after the Philadelphia Centennial Exposition of 1876, when Americans were introduced to the British arts and crafts movement and the work of the Royal School of Needlework, which inspired a revival in decorative embroidery. Celestine Bacheller's crazy quilt is unique in depicting an actual landscape, that of the Massachusetts coastline near Lynn. It is a style of quilt known as a contained crazy because it is composed of a series of squares, each with a different scene.

Unidentified artist

(active mid-nineteenth century)

Meditation by the Sea, 1860s
Oil on canvas
13⅝ x 19⅝ in. (34.6 x 49.8 cm)
Gift of Maxim Karolik for the M. and M.
Karolik Collection of American Paintings,
1815–1865 45.892

This small, moody painting was based on a topographical print of Gay Head (now called Aquinnah, its original Indian name) on Martha's Vineyard, Massachusetts. The print,

published in the September 1860 issue of *Harper's New Monthly Magazine*, is a pleasing, if undistinguished, landscape vignette. It nonetheless inspired this disquieting fantasy that has come to be regarded as a masterpiece of folk painting.

The unidentified painter of *Meditation by the Sea* seems to have had some formal training, though not enough to be fully in command of the expressive effects of his technique. The single-point perspective he used to describe the recession of cliffs into the distance creates a sense of vast space, but it also propels

the viewer's eye past the human figure toward some odd, lava-like rocks parading along the horizon. The disjunctions of scale—the figure is unnaturally small in relation to the cliffs, the stylized surf, and the dead branch at upper left—add to the surreal quality of the image.

James Henry Wright
(1813–1883)

U.S Ship "Constellation," 1850s
Oil on canvas
20⅛ x 29⅞ in. (51.1 x 75.9 cm)
Bequest of Martha C. Karolik for the M. and
M. Karolik Collection of American Paintings,
1815–1865 48.495

Nearly as celebrated as *Constitution*, her sister ship, USS *Constellation* was one of the first frigates built for the U.S. Navy, and was launched from Baltimore in 1797. At the turn of the century *Constellation* patrolled the Caribbean, where her capture of the French warship *Insurgent* greatly increased the prestige of the young American navy. Subsequently, she was stationed in the Mediterranean, where she protected U.S. interests against the feared privateers of Tripoli.

In December 1833, attempting a passage between the western coast of Turkey and mountainous islands off Greece, *Constellation* was nearly destroyed in a violent gale. Her safe arrival, after nearly a week in the storm, was due to the heroic seamanship of Captain George Reed (or Read), whose name is inscribed at the bottom of this painting. The artist, possibly the same J. H. Wright who was active as a portrait painter in New York City at mid-century, created this stirring image some twenty years later, after the original square stern of the ship was replaced with the round stern that appears here. Although Wright described the vessel with some of the specificity of traditional ship portraits, his primary goal was to convey the drama of the event. He painted with great brio the shredded mainsail, the broken boom, and especially the hideous buffeting of the ship by the great serpentine wave that writhes across the surface of the painting like a primeval sea monster.

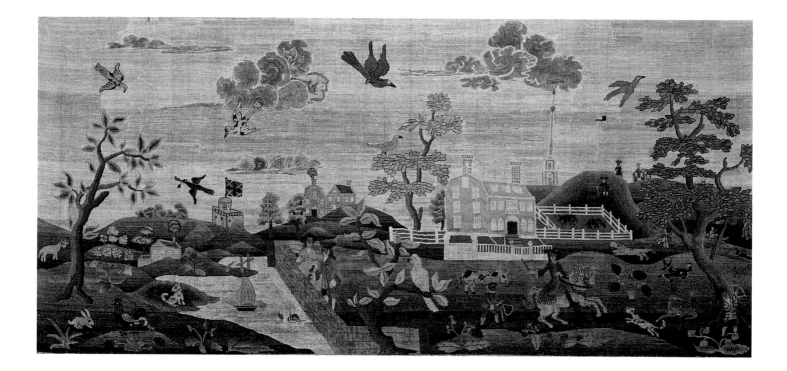

Hannah Otis

(1732–1801)

View of Boston Common, about 1750
Boston, Massachusetts
Linen, plain weave embroidered with silk, wool, metallic thread, and beads
29¼ x 57¾ in. (74.3 x 146.7 cm)

Gift of a Friend of the Department of American Decorative Arts and Sculpture, a Supporter of the Department of American Decorative Arts and Sculpture, Barbara L. and Theodore B. Alfond, and Samuel A. Otis; and William Francis Warden Fund, Harriet Otis Cruft Fund, Otis Norcross Fund, Susan Cornelia Warren Fund, Arthur Tracy Cabot Fund, Seth K. Sweetser Fund, Edwin E. Jack Fund, Helen B. Sweeney Fund, William E. Nickerson Fund, Arthur Mason Knapp Fund, Samuel Putnam Avery Fund, Benjamin Pierce Cheney Fund, and Mary L. Smith Fund
1996.26

Harrison Gray Otis wrote of his great aunt's embroidered chimneypiece, "A view of the Hancock House, and appendages, and of the Common, and its vicinity as they were in 1755–60. It was the boarding school lesson of Hannah Otis, daughter of the Hon. James Otis of Barnstable, educated in Boston. It was considered a chef-d'oeuvre, and made a great noise at the time." The embroidery's reputation as a masterwork continues to this day, because, unlike her fellow students, Hannah Otis probably embroidered an original—and ambitious—design for her project.

The underlying drawings for most embroidered pictures worked by schoolgirls were created by professionals or by their teachers, who took inspiration from printed sources. Otis's picture is a rare example of an original composition based on an actual landscape—that of Boston Common. The picture is dominated by Thomas Hancock's house, built in 1737. Next to it appears the steeple of the West Church and, further to the right, the beacon of Beacon Hill, at the top of which Otis has clearly depicted the tar bucket that held flaming coals. Both structures served as a navigational guide to ships entering Boston harbor: if the steeple lined up with the beacon, it ensured a clear entry into the harbor.

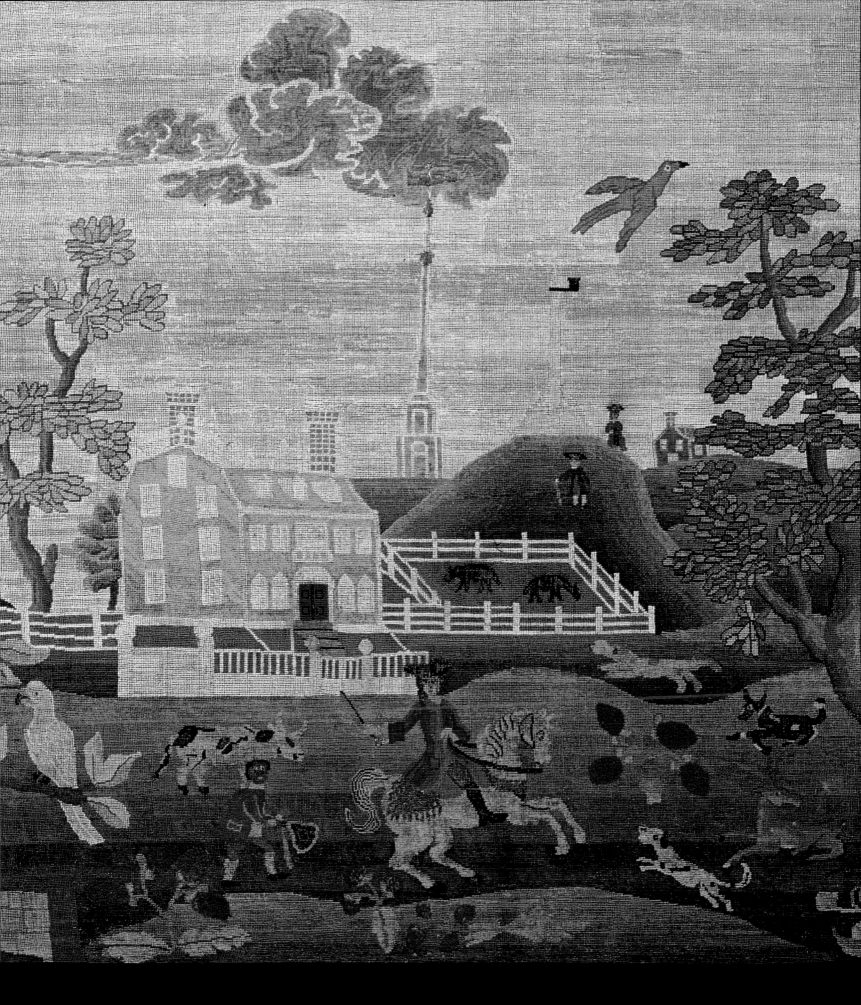

Bountiful
Harvests

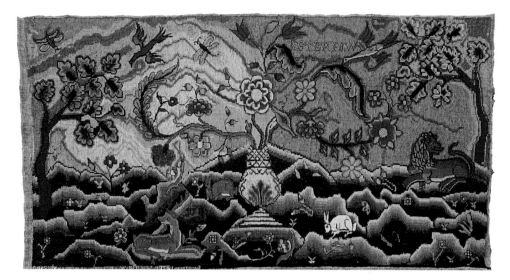

Ester Bernon Powell

(born 1718)

Landscape with animals, about 1735
Providence, Rhode Island
Linen, plain weave embroidered with silk
and wool
17 x 31⅞ in. (43.2 x 79.5 cm)
Gift of Mrs. Samuel Cabot 44.689

This embroidered picture was probably
the handiwork of Ester Bernon Powell of
Providence, Rhode Island. As the daughter
of a well-to-do family, she would have had
the opportunity to attend school and further
her needlework skills. Her family could also
have afforded the canvas (probably imported
ready-drawn from England) and silk yarns
needed to complete this rather large needle-
work picture.

Embroidered pictures featuring a large
vase of flowers were popular in England dur-
ing the early part of the eighteenth century.
However, the incorporation of the vase into
a pastoral landscape with animals, birds, and
insects is unusual. The charm of the image is
further enhanced by Powell's choice of vivid
colors and by the variety of stitches she used
in its execution.

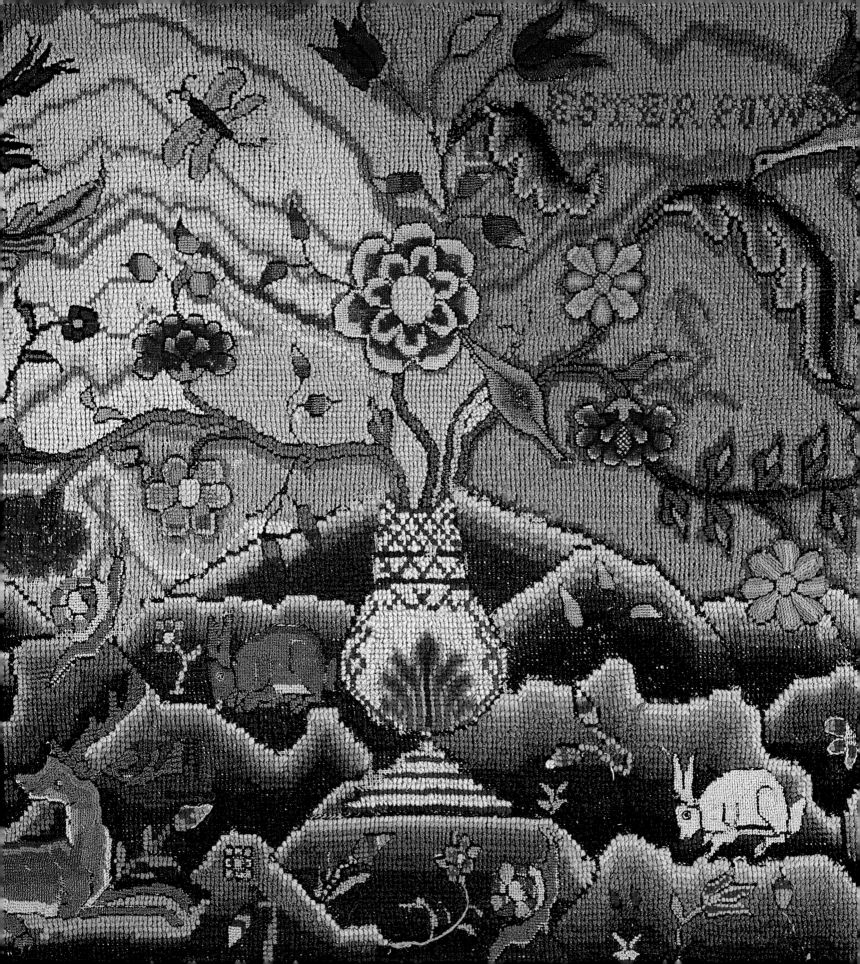

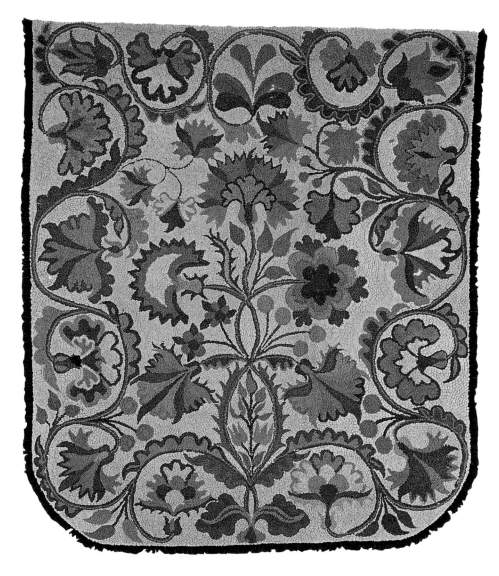

Attributed to Eunice Williams Metcalf

(born about 1775)

Bed rug, 1790–1800
Lebanon, Connecticut
Wool, plain weave embroidered with wool
97 x 85 in. (246.4 x 216 cm)
Susan Cornelia Warren Fund 1980.447

From the seventeenth through the early
nineteenth centuries, the words rugg, rugge,
or rug often referred to a wool bed cover.
The term could also mean a coarse woolen
cloth with a shagged or napped surface, used
for clothing or bedding. Rarely did it denote
a floor covering. Today, the phrase bed rug is
used for embroidered wool bed covers, like
this one. Made throughout the eighteenth
century and into the nineteenth, these rugs
were especially popular in New England,
where the warmth provided by their
embroidered wool pile would have been
welcome. A large proportion of surviving
bed rugs can be traced to the Connecticut
River Valley. Several were made in Lebanon,
Connecticut, and share remarkably similar
designs featuring large, centrally placed flo-
ral trees surrounded by scrolling floral vines.

Unidentified artist

(active eighteenth century)

Chest with drawer, about 1710–30
Southeastern Massachusetts
Painted pine, maple
38 x 40 x 20¼ in. (96.5 x 101.6 x 51.4 cm)
Gift of Miss Mary S. Wheeler and Edward A.
Wheeler 63.1049

Quirky construction details and an expressive painting style turn this utilitarian piece of early eighteenth-century rural furniture into folk art. The as yet unidentified maker, probably from southeastern Massachusetts, used applied moldings and paint to create a facade that resembles an up-to-date chest of drawers, even though the object is actually a more conservative deep chest above a single drawer. Each drawer front, both simulated and real, is outlined with painted dashes and contains a trailing floral design. The two case sides are enlivened with numerous plume-like or comma-shaped ornaments, each a stroke formed by a quick twist of the wrist. Adding eccentricity to the mixture, the maker used standard ball-turned maple feet on the front, but made use of rough, slightly shaped branches from the crotches of trees to form the rear feet.

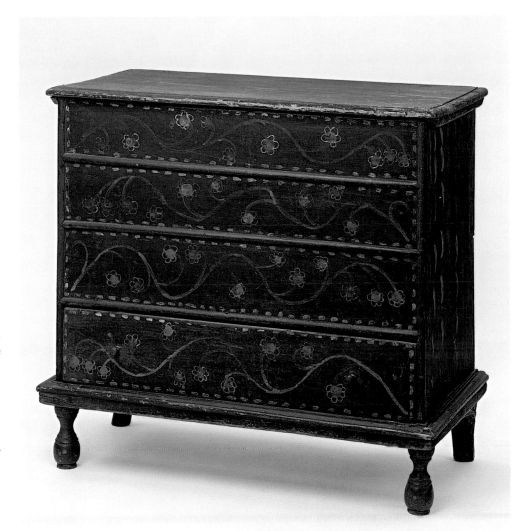

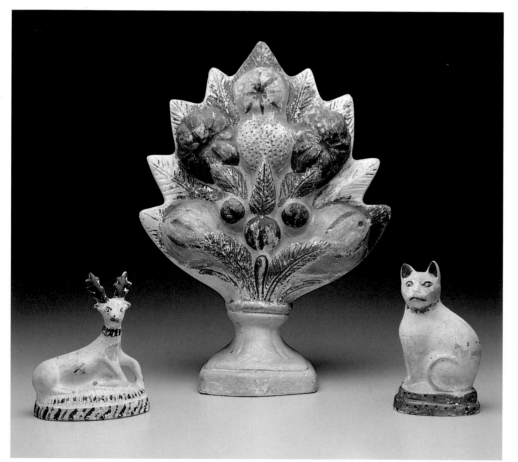

Unidentified artists

(active about 1850–1900)

Deer, 1850–1900
Pennsylvania
Chalkware
5⅛ x 4¼ x 2½ in. (13 x 10.8 x 6.4 cm)
Gift of Maxim Karolik 54.1083

Palmette of fruit and flowers, 1850–1900
Pennsylvania
Chalkware
13⅞ x 4¾ x 4⅝ in. (35.2 x 12.1 x 11.8 cm)
Gift of Maxim Karolik 58.929

Cat, 1850–1900
Pennsylvania
Chalkware
5½ x 3¼ x 2½ in. (14 x 8.3 x 6.4 cm)
Gift of Maxim Karolik 54.1088

"Chalkware" (or plaster of Paris) ornaments were made by both urban craftsmen and itinerant peddlers, often of Italian descent, in the eighteenth and nineteenth centuries. These lightweight ornaments, used as decoration on mantels and elsewhere in the home, were hollow-cast in multi-part molds and then hand-painted in colorful designs. While rare eighteenth-century examples are finely painted and cast, by the second half of the nineteenth century the forms are less crisp and the painting is done with a freer hand. By this time they usually cost from fifteen to fifty cents when new, and were especially popular among middle-class households. They stand at one end of a long series of such decorative figures, ranging from expensive and exquisitely crafted Asian and Meissen porcelain through their more immediate prototypes, the English Staffordshire figurines of the nineteenth century.

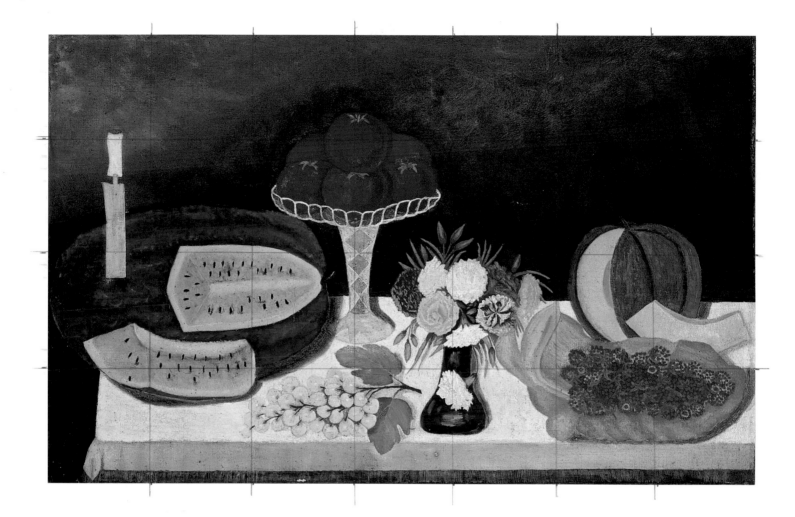

Unidentified artist

(active mid-nineteenth century)

Tomatoes, Fruit, and Flowers, about 1860
Oil on canvas
20 x 31½ in. (50.8 x 80 cm)
Gift of Martha C. Karolik for the M. and M.
Karolik Collection of American Paintings,
1815–1865 47.1265

Interest in still-life paintings burgeoned in mid-nineteenth-century America. Large images of varied objects, like this one, were popular for dining rooms, suggesting abundance, well-being, and hospitality. The compote piled high with fruit, bone-handled knife, melons, grapes with their leaves, and flowers are also found in the work of contemporary academic still-life painters such as Severin Roesen and John F. Francis. Their objects, as here, are arranged against a monochrome background modulated with muted light. Unlike academic still lifes, however, this painting seems more additive than integrated. The emphasis is less on texture and atmosphere—a sense of the whole—than on discrete shapes and emphatic contours.

Although most of the objects in this image are commonplace, paintings including tomatoes are rare, possibly because many people neither liked nor trusted this fruit. In 1852, for example, a Harvard-educated doctor claimed that tomatoes caused teeth to become so loose they could be easily removed with the fingers.

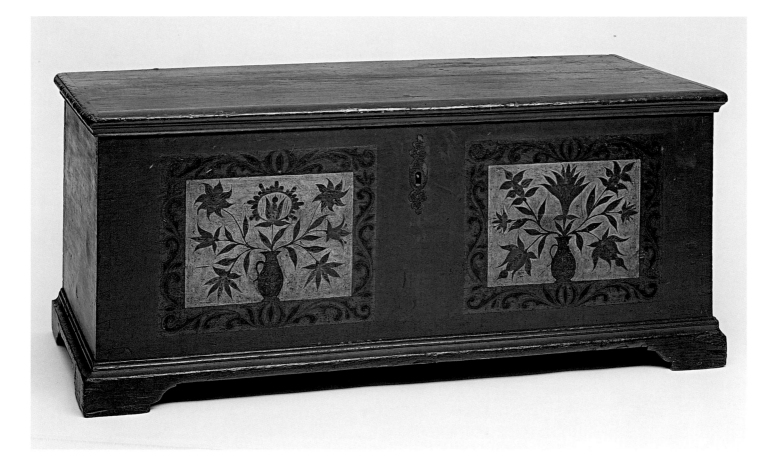

Christian Selzer

(1749–1831)

Chest with drawers, 1783
Jonestown, Dauphin County, Pennsylvania
Painted pine
22 x 52 x 23 in. (55.9 x 132.1 x 58.4 cm)
Bequest of Charles Hitchcock Tyler 32.274

The Pennsylvania Germans formed one of the largest immigrant groups in eighteenth-century America. Decorated chests such as this example were a distinctive type of rural furniture favored by these settlers well into the nineteenth century. Produced in joiners' shops, these chests are fashioned with dove-tailed boards in the continental manner and often embellished with floral, figural, and other motifs related to German frakturs (illuminated manuscripts). These objects, made as wedding or dower chests, are "folk" not only in function but also in their form and ornament. Created for nearly a century in a largely traditional manner, they also exhibit the themes of continuity over time and place characteristic of folk art.

The vase in each panel of this chest is scratched with the name of Christian Selzer (or Seltzer) of Jonestown in Dauphin (now Lebanon) County, Pennsylvania, and the date 1783. He may have made chests as well as painted them, and he was one of four or five decorative painters in southeastern Pennsylvania who, unlike most craftsmen of their time and place, often signed and dated their work. Here, although the red ground surrounding them has been repainted, Selzer's rectangular panels on the front remain in good condition.

God
and Country

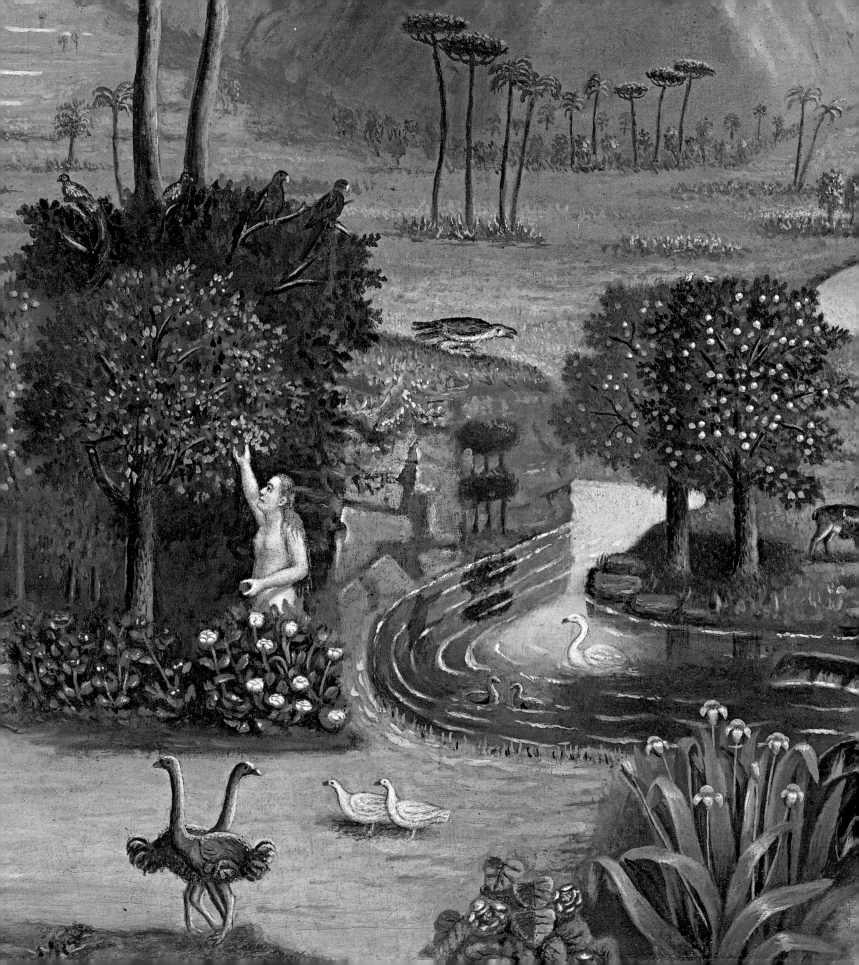

Erastus Salisbury Field

(1805–1900)

The Garden of Eden, about 1860
Oil on canvas
34¾ x 45⅞ in. (88.3 x 116.5 cm)
Gift of Maxim Karolik for the M. and M.
Karolik Collection of American Paintings,
1815–1865 48.1027

And the Lord God planted a garden eastward in Eden;
and there he put the man whom he had formed.

And out of the ground made the Lord God to grow
every tree that is pleasant to the sight, and good for
food; the tree of life also in the midst of the garden,
and the tree of knowledge of good and evil.

Genesis 2:8–9

Inspired by passages from the Bible's Book
of Genesis, *The Garden of Eden* was the first
of many paintings illustrating religious or
moralizing subjects that Field produced after
his wife's death in 1859. In it he combines
motifs borrowed from popular Bible illustra-
tions with his own notion of paradise. Field's
Eden is a well-organized place, with moun-
tains and streams receding with geometric
regularity into a golden distance. Fruit trees
and flowers are in full bloom, and—like a
toy Noah's ark— animals parade in pairs,
domestic species mingling amicably with
their exotic counterparts. The fateful drama
takes place in the center of the picture: Eve
plucks the forbidden fruit from the Tree of
Knowledge, while the serpent, its mission
accomplished, slithers away.

 When the MFA acquired *The Garden of Eden*
from Field's descendants in 1948, paradise
was pure and untroubled: someone, possibly
Field himself, had painted out the offending
figures of Eve and the snake.

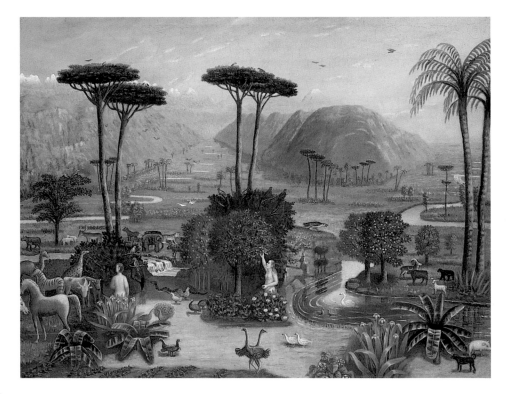

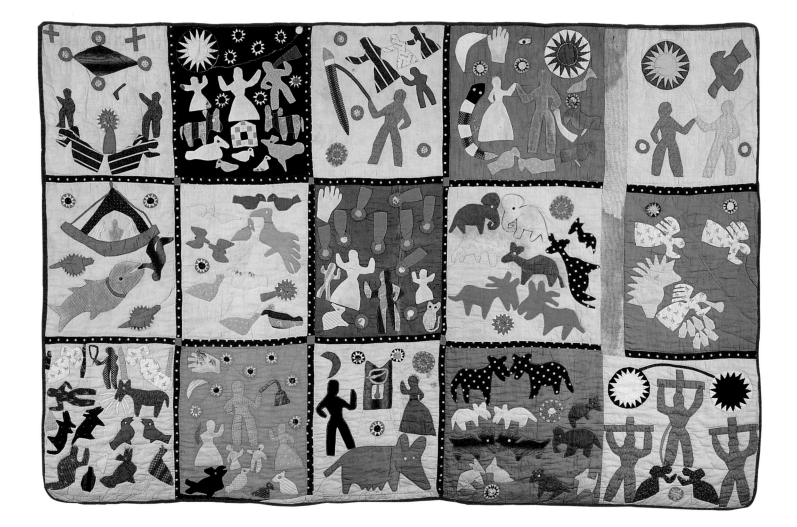

Powers described this scene as: "The falling of the stars on Nov. 13, 1833. The people were frightened and thought that the end had come. God's hand staid the stars. The varmints rushed out of their beds." Accounts of the unprecedented, eight-hour Leonid 1833 meteor shower, passed down through the generations, were part of the oral tradition on which Powers drew for her imagery.

Harriet Powers

(1837–1911)

Pictorial quilt, about 1895–98
Athens, Georgia
Printed, pieced, and appliquéd cotton, hand-
and machine-embroidered with cotton and
metallic yarns
69 x 105 in. (175 x 267 cm)
Bequest of Maxim Karolik 64.619

This extraordinary quilt was created by an African-American woman, born a slave, who with her husband and three children farmed four acres near Athens, Georgia. The quilt is decidedly original in composition and detail; each square tells a complicated story with drama, humor, and the simplest of means. Powers could neither read nor write, but she dictated an explanation of the meanings of her images. Ten squares depict biblical events— stories of Adam and Eve, Noah, Job, Jonah, Moses, and Christ. Others record celebrated natural events such as a meteor shower and an extreme cold snap when "isicles formed from the breath of a mule" and a man was frozen at his jug of liquor. The square in the center of the bottom row features Betts, "the independent hog which ran 500 miles from Ga. to Va."

Although it remains a mystery how Powers would have been aware of this tradition, her textile is strikingly similar in design and technique to the appliquéd cotton cloths made for royalty by the Fon people of Abomey, the ancient capital of Dahomey (now the Republic of Benin) in West Africa. Only two quilts by Harriet Powers are known; the other (at the Smithsonian Institution) was exhibited at the Cotton States Exposition in Atlanta in 1895. It attracted the attention of a group of professors' wives at Atlanta University who commissioned the artist to create this second quilt as a gift to a retiring trustee.

"Adam and Eve in the garden. Eve tempted by the serpent. Adam's rib by which Eve was made. The sun and moon. God's all-seeing eye and God's merciful hand."

Lucy Prouty

(active mid-nineteenth century)

Garden of Paradise, about 1855
Black and white chalk on prepared board
26¼ x 19½ in. (66.7 x 49.5 cm)
The M. and M. Karolik Collection of
American Watercolors and Drawings,
1800–1875 62.114

"Sandpaper drawings" reflect the folk artist's love of unusual materials and techniques. The board on which such chalk drawings were made was prepared with a mixture of varnish and marble dust that gave the surface the roughness and glint of modern sandpaper. What was then called "monochrome drawing" was apparently popular among young women in the mid-nineteenth century and is described in dozens of drawing manuals. Most compositions are derived from prints and magazine illustrations. This one is based on *The Loves of the Angels*, an engraving in the August 1850 issue of *Godey's Lady's Book*.

Garden of Paradise was found in the 1940s near Chester, Vermont. The back of its frame was inscribed with the name Lucy Prouty, who is listed as a student in the Chester Academy catalogue of 1855, the same year that the school offered a course in "monochromatic drawing." Many surviving sandpaper drawings are clumsy and awkward. This graceful example, however, is notable for the artist's skill and confidence in creating dramatic contrasts and a wide range of subtle gradations of black and white.

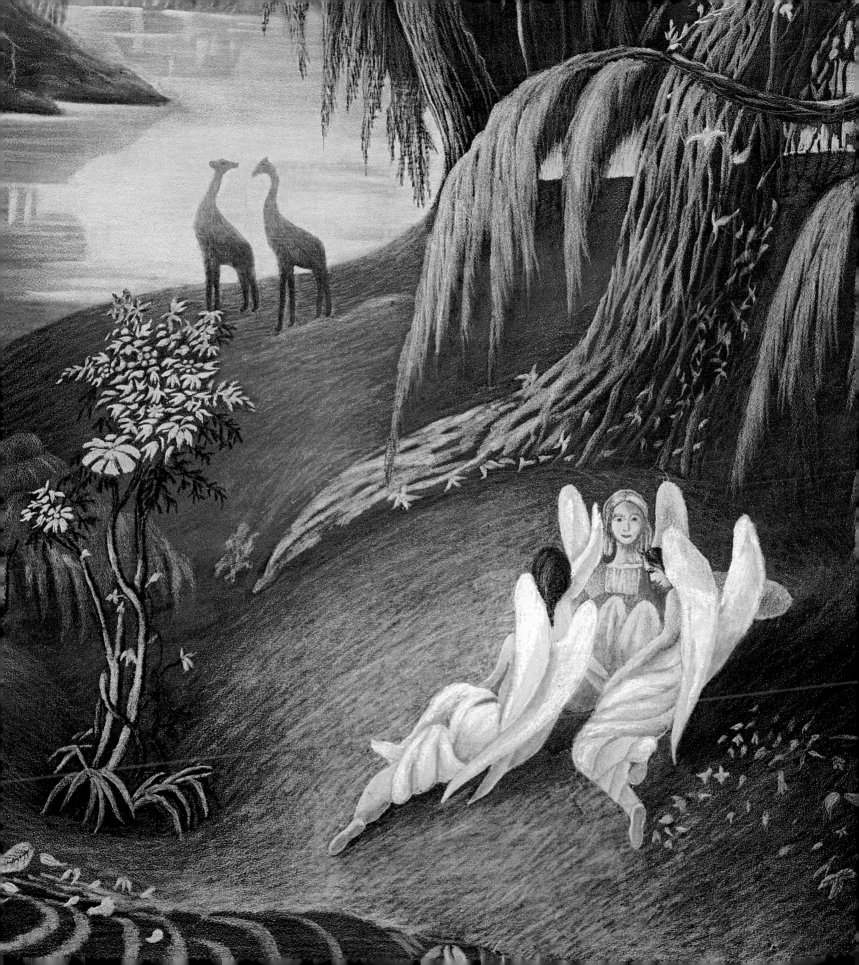

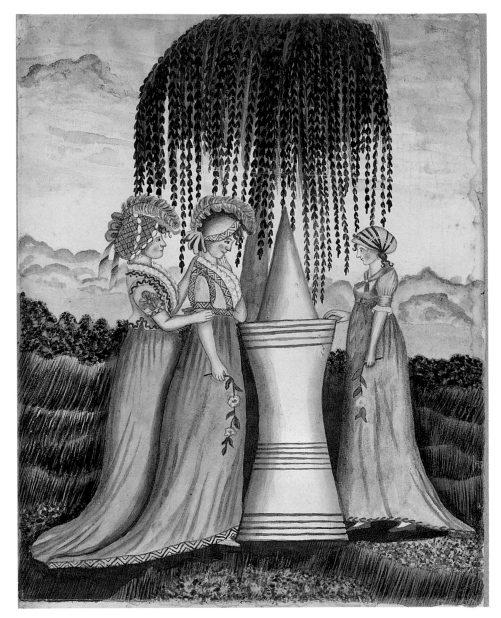

Eunice Griswold Holcombe Pinney
(1770–1849)

Three Women Standing by a Funerary Monument,
about 1800–1810
Watercolor on paper
10¼ x 8⅛ in. (26 x 20.6 cm)
The M. and M. Karolik Collection of
American Watercolors and Drawings,
1800–1875 52.1632

Memorial pictures were traditional subjects of schoolgirl art in the early nineteenth century, and young girls produced them as both embroideries and watercolors. However, Eunice Pinney, who lived all her life in northwestern Connecticut, took up watercolor painting in her thirties. She became especially well known for her memorials, a number of which pay homage to their embroidered counterparts in their use of long, fine, parallel brushstrokes that emulate feathery stitches. Some of Pinney's memorials were modeled after English prints, while others, like this one, seem to have been of her own design.

The three women in Pinney's watercolor wear elegant costumes that were in vogue about 1800 and may have been inspired by a fashion plate. The dresses feature bands of decoration (perhaps embroidered, perhaps applied) at bodice or hem; the caps of the two women at left are adorned with bright-colored ostrich plumes. The figures do not wear traditional mourning garb, which in this era tended to be all black or black and white, but other elements of the picture—the weeping willow, the spray of roses held downward (symbolizing a life cut short), and the oddly shaped funerary monument around which they gather—identify the watercolor as a memorial. Its dedication would have been added later. People in the early nineteenth century had an accepting attitude toward death, and memorials were often made in advance, pragmatically anticipating future use.

Attributed to Eliza Hall

(1810–1837)

Mourning picture, 1823
Boston, Massachusetts
Silk, plain weave embroidered with silk;
hand-painted
11⅞ x 10 in. (30.2 x 22.8 cm)
Gift of Miss Florence Chase 42.643

A weeping willow, a tomb or memorial, and grieving figures served as characteristic elements of the early nineteenth-century mourning picture. The fashion for mourning imagery originated shortly after the death of George Washington in 1799, when engraved prints memorializing the first president began to appear. These works, often copied in silk or watercolor by schoolgirls, eventually inspired a new genre of art devoted to the memory of family and friends.

This embroidered mourning picture and the painted one illustrated on the preceding page present images typical of the genre, but in unexpected form. The needlework picture is embroidered in black silk to resemble an ink drawing, while the watercolor by Eunice Pinney exhibits the shimmering hues usually found in polychrome silk embroidery.

Georg Friederich Speyer

(active 1785–1800)

Birth and Baptism Certificate of Johannes Seÿbert,
about 1770
Pen and watercolor on paper
13 x 16¹⁄₁₆ in. (33 x 40.8 cm)
The M. and M. Karolik Collection of
American Watercolors and Drawings,
1800–1875 56.770

Durs Rudy

(1789–1850)

A Baptism, about 1820
Pen and opaque watercolor on paper
7⅞ x 9¹³⁄₁₆ in. (20 x 24.9 cm)
The M. and M. Karolik Collection of
American Watercolors and Drawings,
1800–1875 56.773

Frakturs date back to sixteenth-century
documents in Europe, and the term *frak-
tur-schriften* ("fraktur writing") refers to a
specific typeface that was used for official
family records. Eventually, the term "frak-
tur" came to signify both the typeface
and the documents. Birth and baptismal
records often included poems or religious
verse that welcomed new members into
society. A line from the Seÿbert certificate

(at left) reads, "I am baptized, and should I immediately die, what harm is there in the cold grave? I know my homeland and inheritance await me after my death with God in Heaven…." Frakturs were commonly attached inside the lid of blanket chests, or kept in a drawer or Bible. The examples shown here include such typical embellishments as flowers and birds. However, the fanciful mermaids that enliven Speyer's watercolor are seldom found in other artists' frakturs.

The makers of these baptismal certificates were active in Pennsylvania. Speyer, who painted many frakturs, traveled to Philadelphia from Germany in 1752 and served in a Berks County regiment in 1776. By 1800 he was active as a printer. Rudy was born in Baden, Germany, and arrived in Philadelphia in 1803. As with many folk artists, Rudy made his living in several different trades. He owned and ran a country store and tavern in Unionville, Pennsylvania, and was also highly regarded as a painter of frakturs. Before Maxim Karolik acquired these two works, they belonged to the early twentieth-century artist Elie Nadelman, an avid collector and promoter of folk art.

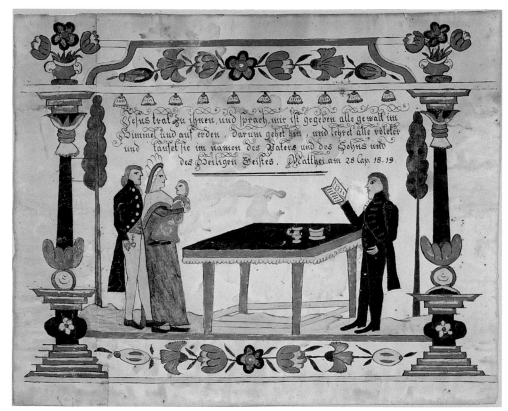

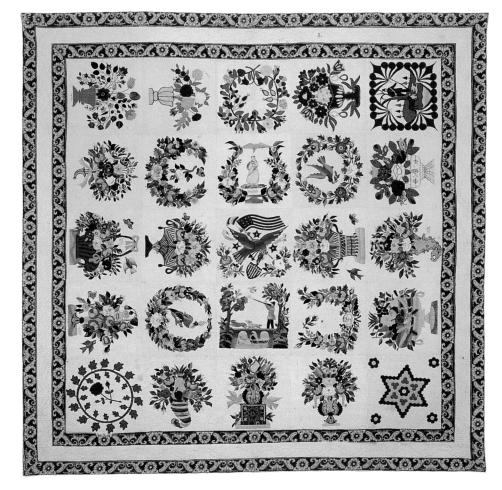

Mary Simon and others

(active nineteenth century)

Album quilt, about 1847–50
Baltimore, Maryland
Cotton plain weave pieced, appliquéd,
and embroidered; ink
104 x 103 in. (264.2 x 261.6 cm)
Museum purchase with funds donated
anonymously 1999.531

Album quilts, like autograph books, came
into fashion during the first half of the nine-
teenth century and were popular along the
Atlantic seaboard and as far west as Ohio.
They were constructed of squares that were
pieced or appliquéd by different makers. This
quilt shares many characteristics with others
created in Baltimore, Maryland, between
1847 and 1852. All of these quilts contain
squares composed with a fine artistic sense,
not only in their designs of baskets, cornu-
copias, and bouquets, but also in the choice
of fabrics combined to create them. Certain
elements such as triple-knotted bows, fine
inked lines, and dominant white roses also
are characteristic. Current research has iden-
tified the designer of these quilt squares as
Mary Simon, who appears to have sold "quilt
kits" to Baltimore ladies. Some of the most
popular squares designed by Simon, exhibit-
ing such patriotic themes as the bald eagle
clutching the American flag (inspired by the
seal of the United States) or the goddess of
Liberty, found their way into the center of
the Baltimore quilts. Patriotic sentiment in
the city was high at this time, when many
of its young men were marching off to fight
in the Mexican War of 1846–48.

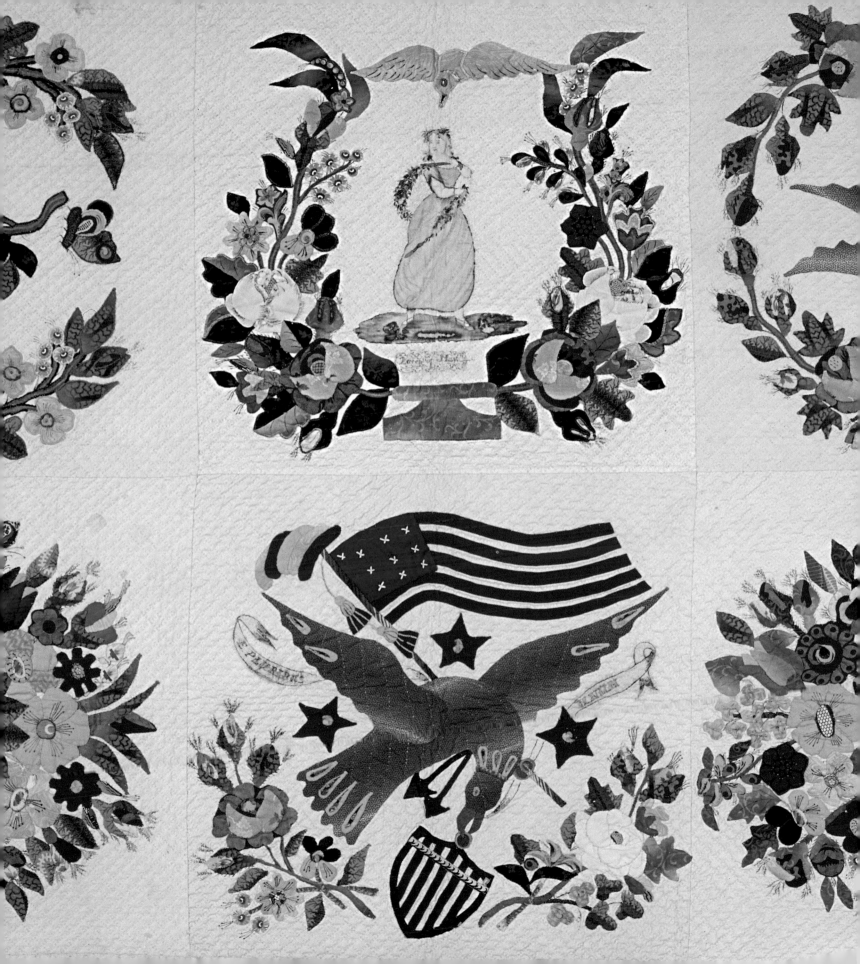

Wilhelm Schimmel

(1817–1890)

Eagle with spread wings, 1860–90
Cumberland County, Pennsylvania
Painted pine
22⅛ x 29 in. (56.2 x 73.7 cm)
Gift of Maxim Karolik 59.945

Although Wilhelm Schimmel (see page 49) is thought to have carved more than five hundred eagles—to say nothing of his roosters, squirrels, and other animal figures—the works credited to him are not signed or labeled, and so attributions have to be made on the basis of style and, occasionally, provenance. This imposing and fierce eagle, one of the largest attributed to Schimmel, exhibits the characteristics that identify his work. The pine body is whittled in a typical manner of notches cut quickly with a pocket jackknife, creating a cross-hatched pattern, while each feather on the wings is carefully articulated. It is thought that Schimmel polished his carvings with a piece of glass before applying a layer of gesso; the object was then painted. Schimmel is usually described as an untrained amateur, but his work owes much to related European vernacular carvings from Bavaria and the Alpine region.

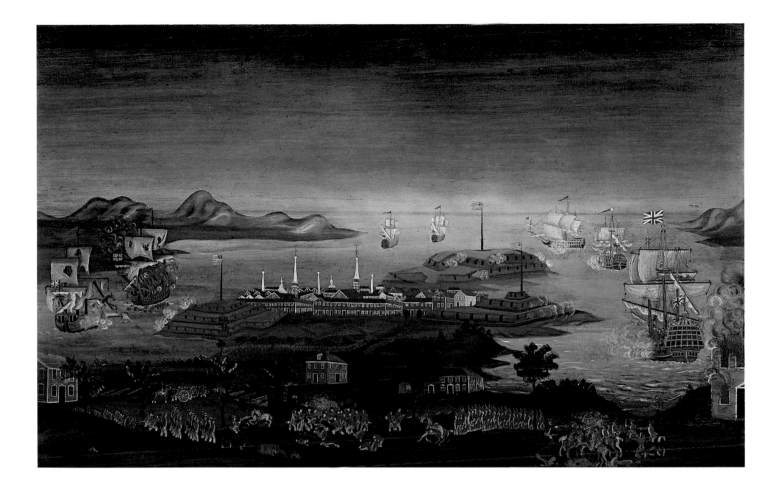

Winthrop Chandler

(1747–1790)

The Battle of Bunker Hill, about 1776–77
Oil on panel
34⅞ x 53⅝ in. (88.6 x 136.2 cm)
Gift of Mr. and Mrs. Gardner Richardson
1982.281

The battle of Bunker Hill was still news when Winthrop Chandler painted this panoramic view to decorate a cousin's house in Pomfret, Connecticut. Although Chandler was primarily a portrait painter, he is also credited with about nine landscapes, among the earliest in a folk idiom known in America. This scene was painted on a fireboard used to cover a fireplace opening during the summer

months; it was later installed above the fireplace as an overmantel. Although Chandler may have spent time in Boston during the 1760s, the Connecticut-based artist was not present at the battle of Bunker Hill. Nor, apparently, was his composition inspired by a print. This scene is his own notion of the military engagement, one of the most costly British victories of the war.

While Chandler's view is not accurate from either a military or a topographical standpoint (the spectator seems to be looking down over Charlestown from Breed's Hill, where the battle actually took place), it conveys the drama of the event through telling detail. Wounded soldiers and riderless horses are scattered across the fore-

ground. British ships blast the shoreline with cannon fire, while tiny figures cling to the rigging or flail in the water. At right, a house bursts into flame, a prelude to the bombardment of Charlestown. And, spaced neatly throughout the picture are the three forts that guarded the harbor, each proudly flying the Grand Union flag. The flag, with thirteen stripes signifying the original colonies and the crosses of Saint George and Saint Andrew representing the Crown, suggests a date for the picture: it was the colonial standard until June 14, 1777, when the Continental Congress adopted the Stars and Stripes.

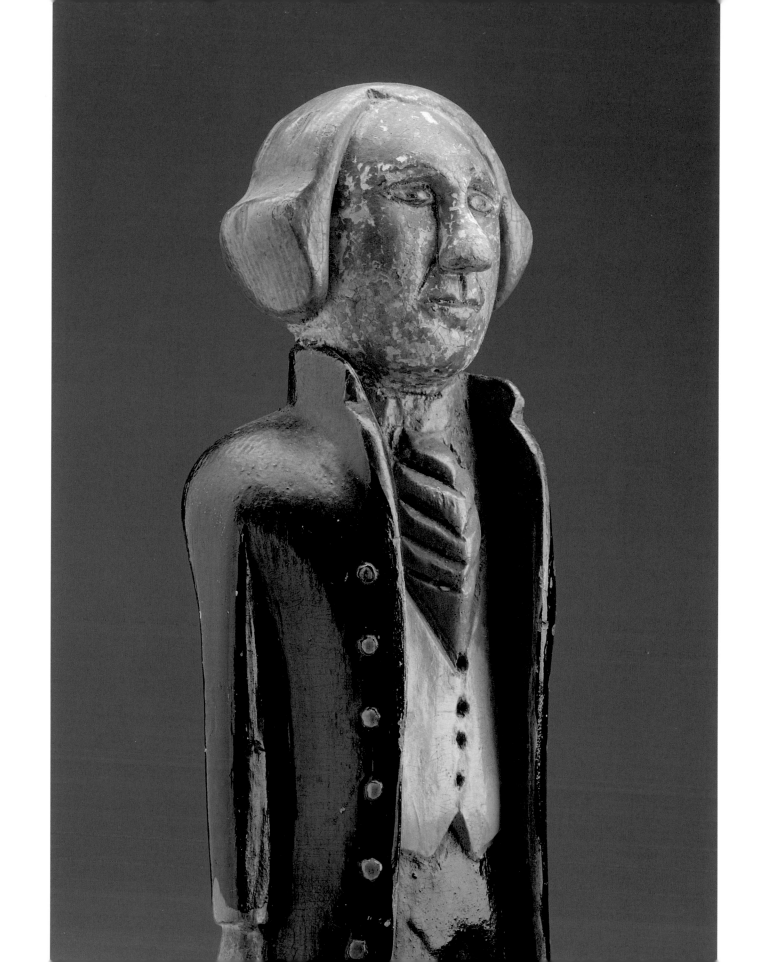

Unidentified artist

(active late nineteenth century)

George Washington, 1870–1900
Possibly Pennsylvania
Painted wood
13⅞ x 3 x 3 in. (35.2 x 7.6 x 7.6 cm)
Gift of Maxim Karolik 60.489

Unidentified artist

(active late nineteenth century)

Abraham Lincoln, 1875–1900
United States
Painted wood
14¾ x 4 x 4 in. (37.5 x 10.2 x 10.2 cm)
Gift of Maxim Karolik 55.800

A substantial portion of folk sculpture is comprised of images of our national leaders and heroes. Of that pantheon, no figure was more popular than George Washington. Images of the "Father of Our Country" were produced in many media both during his lifetime and throughout the nineteenth century. This tall, attenuated figure of Washington, with his hands held closely to his sides, was probably made in the late nineteenth century, perhaps near the time of the Centennial celebrations in 1876. According to the dealer from whom it was purchased, it came from Cornwall, Pennsylvania.

The figure of Abraham Lincoln is similar in spirit but represents the work of another amateur carver and painter. It shows the Great Emancipator at a young age, without a beard, and with his hands tucked jauntily into his pockets. The back of this sculpture is flat, as if it were meant to go against a wall.

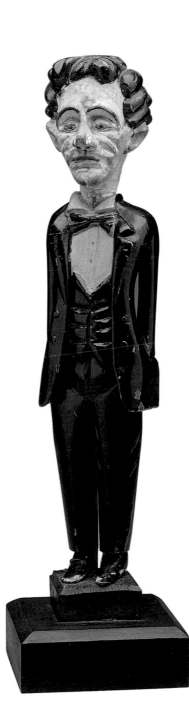

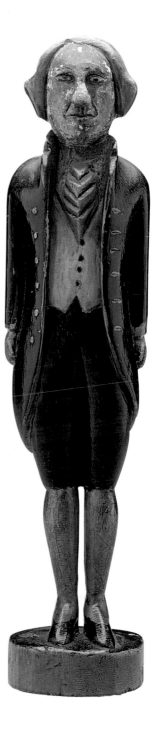

Suggested Reading

The following selective bibliography includes many general works on American folk art before about 1920, as well as more specialized monographs that were consulted in the preparation of this publication. Additional information about specific objects illustrated in this book is contained in the various publications about the Museum's collections cited in the notes to the introductory essay. Many relevant articles are found in the pages of such journals as *The Magazine Antiques*, *Folk Art* (originally published as *The Clarion*), *Winterthur Portfolio*, and the *Folk Art Messenger* (for twentieth-century material). For a historiographical overview and many additional suggestions, see Simon J. Bronner, *American Folk Art: A Guide to Sources* (New York: Garland Publishing, 1984).

Marie Jeanne Adams. "The Harriet Powers Pictorial Quilts." *Black Art* 3, no. 4 (1979): 12–28.

American Folk Art: The Art of the Common Man in America. New York: Museum of Modern Art, 1932.

American Folk Paintings: Paintings and Drawings Other Than Portraits from the Abby Aldrich Rockefeller Folk Art Center. Boston: New York Graphic Society in association with the Colonial Williamsburg Foundation, 1988.

American Folk Portraits from the Abby Aldrich Rockefeller Folk Art Center. Boston: New York Graphic Society in association with the Colonial Williamsburg Foundation, 1981.

American Folk Sculpture: The Work of Eighteenth- and Nineteenth-Century Craftsmen. Newark, N.J.: Newark Museum, 1931.

American Primitives: An Exhibit of the Paintings of Nineteenth-Century Folk Artists. Newark, N.J.: Newark Museum, 1931.

An American Sampler: Folk Art from the Shelburne Museum. Washington, D.C.: National Gallery of Art, 1987.

Kenneth L. Ames. *Beyond Necessity: Art in the Folk Tradition*. Winterthur, Del.: Winterthur Museum, 1977.

Ruth Andrews, ed. *How to Know American Folk Art: Eleven Experts Discuss Many Aspects of the Field*. New York: E.P. Dutton, 1977.

Robert Bishop. *American Folk Sculpture*. New York: E.P. Dutton, 1974.

Robert Bishop and Jacqueline Marx Atkins, with the assistance of Henry Niemann and Patricia Coblentz. *Folk Art in American Life*. New York: Viking Studio Books in association with the Museum of American Folk Art, New York, 1995.

Robert Bishop and Patricia Coblentz. *A Gallery of American Weathervanes and Whirligigs*. New York: E.P. Dutton, 1981.

Robert Bishop, Judith Reiter Weissman, Michael McManus, and Henry Niemann. *Folk Art: Paintings, Sculpture, and Country Objects*. Knopf Collectors' Guides to American Antiques. New York: Alfred A. Knopf, 1983.

Mary Black. *Erastus Salisbury Field: 1805–1900*. Springfield, Mass.: Museum of Fine Arts, 1984.

Deborah Chotner et al. *American Naïve Paintings: The Collections of the National Gallery of Art: Systematic Catalog*. Washington, D.C.: National Gallery of Art, 1992.

Common Ground/Uncommon Vision: The Michael and Julie Hall Collection of American Folk Art. Milwaukee, Wis.: Milwaukee Art Museum, 1993.

Paul S. D'Ambrosio and Charlotte M. Emans. *Folk Art's Many Faces: Portraits in the New York State Historical Association*. Cooperstown, N.Y.: New York State Historical Association, 1987.

C. Kurt Dewhurst, Betty Macdowell, and Marsha Macdowell. *Religious Folk Art in America: Reflections of Faith*. New York: E.P. Dutton in association with the Museum of American Folk Art, 1983.

Adele Earnest. *The Art of the Decoy: American Bird Carvings*. New York: Clarkson N. Potter, 1965.

Joe Engers, ed. *The Great Book of Wildfowl Decoys*. San Diego, Cal.: Thunder Bay Press, 1990.

Monroe H. Fabian. *The Pennsylvania German Decorated Chest*. New York: Universe Books, 1978.

Dean A. Fales, Jr. *American Painted Furniture, 1660–1880*. New York: E.P. Dutton, 1972.

Milton E. Flower. *Wilhelm Schimmel and Aaron Mountz, Wood Carvers*. Williamsburg, Va.: Abby Aldrich Rockefeller Folk Art Collection, 1965.

Tobin Fraley. *The Great American Carousel: A Century of Master Craftsmanship*. San Francisco: Chronicle Books, 1994.

Frederick Fried. *Artists in Wood: American Carvers of Cigar-Store Indians, Show Figures, and Circus Wagons*. New York: Bramhall House, 1970.

Gladys-Marie Fry. "Harriet Powers: Portrait of a Black Quilter." In *Missing Pieces: Georgia Folk Art, 1770–1976*, pp. 17–23. Atlanta: Georgia Council for the Arts and Humanities, 1976.

Beatrice B. Garvan. *The Pennsylvania German Collection*. Philadelphia: Philadelphia Museum of Art, 1982.

Tom Geismar, Harvey Kahn, and Ralph Sessions. *Spiritually Moving: A Collection of American Folk Art Sculpture*. New York: Harry N. Abrams, 1998.

Henry Glassie. "Folk Art." In *Folklore and Folklife: An Introduction*, ed. Richard M. Dorson, pp. 253–80. Chicago: University of Chicago Press, 1972.

Henry Glassie. *Pattern in the Material Folk Culture of the Eastern United States*. Philadelphia: University of Pennsylvania Press, 1968.

Henry Glassie. *The Spirit of Folk Art: The Girard Collection at the Museum of International Folk Art*. New York: Harry N. Abrams in association with the Museum of New Mexico, Sante Fe, 1989.

Jennifer F. Goldsborough. "An Album of Baltimore Album Quilt Studies." *Uncoverings* 15 (1994): 73–110.

Georgeanna H. Greer. *American Stonewares: The Art and Craft of Utilitarian Potters*. Exton, Pa.: Schiffer Publishing, 1981.

Herbert W. Hemphill, Jr., ed. *Folk Sculpture USA*. Brooklyn, N.Y.: Brooklyn Museum, 1976.

Colleen Cowles Heslip. *Between the Rivers: Itinerant Painters from the Connecticut to the Hudson*. Williamstown, Mass.: Sterling and Francine Clark Art Institute, 1990.

Stacy C. Hollander. "Mary Ann Willson, Artist Maid." *Folk Art* 23, no. 2 (summer 1998): 20–23.

Stacy C. Hollander and Howard P. Fertig. *Revisiting Ammi Phillips: Fifty Years of American Portraiture*. New York: Museum of American Folk Art, 1994.

John Hunter and Gene Kangas. *New World Folk Art: Old World Survivals and Cross-Cultural Inspirations, 1492–1992*. Cleveland, Ohio: Cleveland State University Art Gallery, 1992.

Dena S. Katzenberg. *Baltimore Album Quilts*. Baltimore, Md.: Baltimore Museum of Art, 1981.

Myrna Kaye. *Yankee Weathervanes*. New York: E.P. Dutton, 1975.

Helen Kellogg. "Found: Two Lost American Painters [Ruth and Samuel Shute]." *Antiques World* 1 (December 1978): 36–47.

Jill Beute Koverman, ed. *"I made this jar . . .": The Life and Works of the Enslaved African-American Potter, Dave*. Columbia, S.C.: McKissick Museum, University of South Carolina, 1998.

Dean Lahikainen. *In the American Spirit: Folk Art from the Collections*. Salem, Mass.: Peabody Essex Museum, 1994.

Shelley R. Langdale. "The Enchantment of the Magic Lake: The Origin and Iconography of a Nineteenth-Century Sandpaper Drawing." *Folk Art* 23, no. 4 (winter 1998–1999): 52–62.

Amanda E. Lange and Julie A. Reilly. "Whimsy in Plaster: Researchers Rediscover an American Folk Art." *Winterthur Magazine* 39, no. 4 (fall 1993): 8–9.

Wendy Lavitt. *Animals in American Folk Art*. New York: Alfred A. Knopf, 1990.

Jean Lipman, Robert Bishop, Elizabeth V. Warren, and Sharon L. Eisenstat. *Five Star Folk Art: One Hundred American Masterpieces*. New York: Harry N. Abrams in association with the Museum of American Folk Art, 1990.

Jean Lipman and Alice Winchester. *The Flowering of American Folk Art, 1776–1876*. New York: Viking Press in cooperation with the Whitney Museum of American Art, 1974.

Jean Lipman and Thomas Armstrong, eds. *American Folk Painters of Three Centuries*. New York: Hudson Hills Press in association with the Whitney Museum of American Art, 1980.

Nina Fletcher Little. *American Decorative Wall Painting, 1700–1850*. Sturbridge, Mass.: Old Sturbridge Village in cooperation with Studio Publications, 1952. Rev. ed. New York: E.P. Dutton, 1972.

Nina Fletcher Little. *Country Arts in Early American Homes*. New York: E.P. Dutton, 1975.

Nina Fletcher Little. "John Brewster, Jr., 1766–1854: Deaf-Mute Portrait Painter of Connecticut and Maine." *Connecticut Historical Society Bulletin* 25 (October 1960): 97–129.

Nina Fletcher Little. *Little by Little: Six Decades of Collecting American Decorative Arts*. New York: E.P. Dutton, 1984.

Nina Fletcher Little. "Winthrop Chandler, Limner of Windham County, Connecticut." *Art in America* 35 (April 1947): 75–168.

Richard Muhlberger. *American Folk Marquetry: Masterpieces in Wood*. New York: Museum of American Folk Art, 1998.

Marion Nelson, ed. *Norwegian Folk Art: The Migration of a Tradition.* New York: Abbeville Press in association with the Museum of American Folk Art, New York, and the Norwegian Folk Museum, Oslo, 1995.

Jacquelyn Oak. *Sotheby's Guide to American Folk Art.* New York: Simon & Schuster, 1994.

Amelia Peck. *American Quilts and Coverlets.* New York: Metropolitan Museum of Art and Dutton Studio Books, 1990.

Sam Pennington. *April Fool: Folk Art Fakes and Forgeries.* Waldoboro, Me.: Maine Antique Digest, 1988.

Ian M. G. Quimby and Scott T. Swank, eds. *Perspectives on American Folk Art.* New York: W. W. Norton for the Henry Francis du Pont Winterthur Museum, 1980.

Betty Ring. *American Needlework Treasures: Samplers and Silk Embroideries from the Collection of Betty Ring.* New York: E.P. Dutton in association with the Museum of American Folk Art, 1987.

Betty Ring. *Girlhood Embroidery: American Samplers and Pictorial Needlework, 1650–1850.* 2 vols. New York: Alfred A. Knopf, 1993.

Beatrix T. Rumford and Carolyn J. Weekley. *Treasures of American Folk Art from the Abby Aldrich Rockefeller Folk Art Center.* Boston: Little, Brown and Company, Bulfinch Press, in association with the Colonial Williamsburg Foundation, 1989.

Three New England Watercolor Painters. Chicago: Art Institute of Chicago, 1974.

Gertrude Townsend. "Notes on New England Needlework Before 1800." *Bulletin of the Needle and Bobbin Club* 28, nos. 1–2 (1944): 2–23.

Robert F. Trent. *Hearts and Crowns: Folk Chairs of the Connecticut Coast, 1720–1840, as Viewed in the Light of Henri Focillon's Introduction to Art Populaire.* New Haven: New Haven Colony Historical Society, 1977.

John Michael Vlach. *Plain Painters: Making Sense of American Folk Art.* Washington, D.C.: Smithsonian Institution Press, 1988.

William L. Warren. *Bed Ruggs/1722–1833.* Hartford, Conn.: Wadsworth Atheneum, 1972.

Frederick S. Weiser. *Fraktur: Pennsylvania German Folk Art.* Ephrata, Pa.: Science Press, 1973.

Catherine Zusy. *Norton Stoneware and American Redware: The Bennington Museum Collection.* Bennington, Vt.: Bennington Museum, 1991.

Figure Illustrations

1. William Mathew Prior (1806–1873)
William Allen, 1843
Oil on canvas
32¼ x 40⅛ in. (81.9 x 101.9 cm)
Bequest of Martha C. Karolik for the M. and
M. Karolik Collection of American Paintings,
1815–1865 48.466

2. Attributed to John Neis (1785–1867)
Plate, 1834
Upper Salford Township, Montgomery
County, Pennsylvania
Redware with slip and sgrafitto decoration
Diam. 10¾ in (27.3 cm)
Anonymous gift 02.323

3. Katherine Greene (1731–1777)
Coat of arms, 1745
Boston, Massachusetts
Linen, plain weave embroidered with silk,
wool, and beads
19⅜ x 18⅛ in. (49.2 x 46 cm)
The M. and M. Karolik Collection of
Eighteenth-Century American Arts 39.243

4. Mr. Willson (active early nineteenth
century)
Miss Mary Furber, about 1822
Watercolor on paper
25¼ x 19⅝ in. (64.1 x 49.8 cm)
The M. and M. Karolik Collection of Amer-
ican Watercolors and Drawings, 1800–1875
60.447

5. Unidentified artist (active late nineteenth
century)
Fox on Log, about 1850–1900
United States
Wood, gessoed and painted
15½ x 29 x 9½ in. (39.4 x 71.8 x 24.1 cm)
Gift of Maxim Karolik 53.2526

6. Attributed to Pierre Antoine Petit, called
La Lumière (died 1815)
Buffet, about 1800
Vincennes, Indiana
Yellow-poplar, curly maple
46¼ x 48 x 24¼ in. (117.5 x 121.9 x 61.6 cm)
Gift of Daniel and Jesse Lie Farber and Frank B.
Bemis Fund 1989.50

7. Heinrich Kuenemann II (1843–1914)
Wardrobe, about 1870
Fredericksburg, Texas
Pine
87¼ x 56½ x 23½ in. (221.6 x 143.5 x 59.7 cm)
Gift of Mrs. Charles L. Bybee 1990.483

8. Possibly by Alexander Masterton (1797–1859)
Napoleon, about 1825–50
Eastchester, New York
Limestone
19 x 6 x 6 in. (48.3 x 15.2 x 15.2 cm)
William E. Nickerson Fund 1986.238

9. Dave the Potter (about 1783–about 1863)
for the Lewis J. Miles Factory
Storage jar, 1857
Edgefield County, South Carolina
Stoneware with alkaline glaze
19 x diam. base 10¼ in. (48.3 x diam. base
26 cm)
Harriet Otis Cruft Fund and Otis Norcross Fund
1997.10

10. James Stephen Ginder (1871–1949)
Uncle Sam, about 1943
North Reading, Massachusetts
Pine
89¼ x 32¾ x 18 in. (226.7 x 83.2 x 45.7 cm)
Harriet Otis Cruft Fund 67.763

Index of Identified Artists

About the Authors

GERALD W. R. WARD is Katharine Lane Weems Curator of Decorative Arts and Sculpture, Art of the Americas, at the Museum of Fine Arts, Boston. His previous books include *American Case Furniture in the Mabel Brady Garvan and Other Collections at Yale University* and, as editor, *Perspectives on American Furniture* and *The American Illustrated Book in the Nineteenth Century*.

ABAIGEAL DUDA is a research fellow and special coordinator for the exhibition "American Folk."

PAMELA A. PARMAL is Curator of Textile and Fashion Arts at the Museum of Fine Arts, Boston, and the author of *Samplers from A to Z*.

SUE WELSH REED is Curator of Prints and Drawings at the Museum of Fine Arts, Boston. Her previous books include *Italian Etchers of the Renaissance and Baroque* (with Richard Wallace), *Awash in Color: Homer, Sargent, and the Great American Watercolor* (with Carol Troyen), and *French Prints from the Age of the Musketeers*.

GILIAN FORD SHALLCROSS is Manager of Exhibition Resources at the Museum of Fine Arts, Boston, and the author of *MFA: A Guide to the Collection of the Museum of Fine Arts, Boston*.

CAROL TROYEN is Curator of Paintings, Art of the Americas, at the Museum of Fine Arts, Boston. Her publications include *Awash in Color* (with Sue Welsh Reed), *Sargent's Murals in the Museum of Fine Arts, Boston*, *Charles Sheeler: Paintings and Drawings*, and, in collaboration, *American Paintings in the Museum of Fine Arts, Boston*.

Acknowledgments

Many Museum staff members have contributed their efforts to the production of this book. In particular we are grateful for the support and encouragement offered by Malcom Rogers, Ann and Graham Gund Director, and Katie Getchell, Deputy Director for Curatorial Administration. The knowledge and skills of conservation staff members Gordon Hanlon, Jon Brandon, Rebecca Fifield, Meredith Montague, and Kimberly Nichols enabled many objects to look their best for Greg Heins, Thomas Lang, and Gary Ruuska, the photographers who sympathetically recorded them in color for publication. *American Folk* has been produced with creativity and care by Mark Polizzotti, Museum publisher; Cynthia Randall, designer; Dacey Sartor, production manager; and copy editor Denise Bergman.

The authors also would like to thank Clifford Ackley, Mark Ashley, Julia Bailey, Laurel Gable, Rebecca Reynolds, Barbara Rotundo, Colin Seis, Seth Waite, and David Wheatcroft for the information and assistance they have provided.